W9-ARD-486

The Campus History Series

CHICAGO STATE
UNIVERSITY

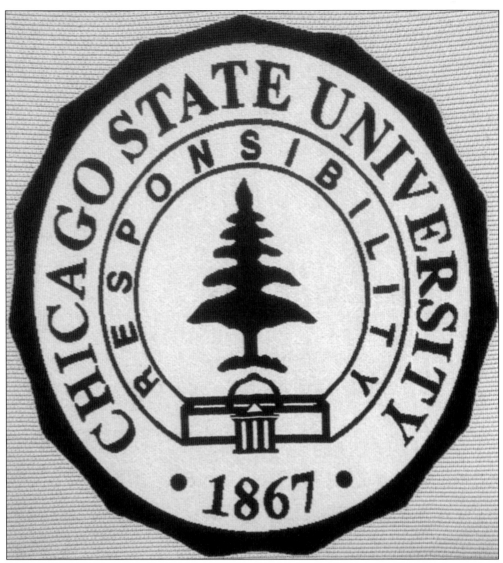

This tapestry with Chicago State University's seal is displayed in Harold Washington Hall. Ever since the school's 1867 founding, the tree has represented knowledge, and the word "responsibility" has guided the university in its mission. (Courtesy of Byung-In Seo.)

ON THE COVER: Pictured is the auditorium in the Dome Building. Here, audiences could enjoy performances by student or professional groups and partake in lectures and information sessions. Note the stage behind the man at the lectern and the stairs going up to the balcony. (Courtesy of Chicago State University Archives and Special Collections.)

COVER BACKGROUND: Chicago Teachers College is pictured in 1905. (Courtesy of Chicago State University Archives and Special Collections.)

The Campus History Series

CHICAGO STATE UNIVERSITY

BYUNG-IN SEO AND AAISHA N. HAYKAL
FOREWORD BY DR. SYLVIA GIST

ARCADIA
PUBLISHING

Copyright © 2018 by Byung-In Seo and Aaisha N. Haykal
ISBN 978-1-4671-2979-4

Published by Arcadia Publishing
Charleston, South Carolina

Printed in the United States of America

Library of Congress Control Number: 2018936888

For all general information, please contact Arcadia Publishing:
Telephone 843-853-2070
Fax 843-853-0044
E-mail sales@arcadiapublishing.com
For customer service and orders:
Toll-Free 1-888-313-2665

Visit us on the Internet at www.arcadiapublishing.com

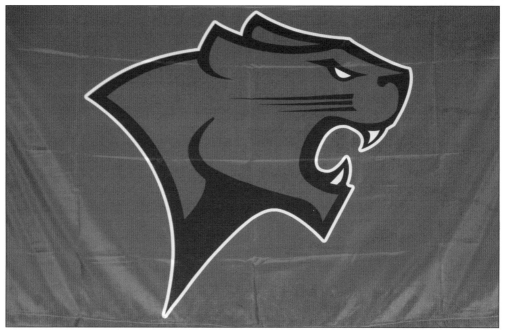

The school's mascot was originally the Colonels, to honor Col. Francis Parker, but in 1971, it was changed to the Cougars. This flag is displayed in the Jacoby D. Dickens Physical Education and Athletic Center. (Courtesy of Byung-In Seo.)

R0454946210

CONTENTS

FOREWORD

This chronicle following the journey of the 1867 normal school in Blue Island, Illinois, to its present form of Chicago State University is a welcome addition to the history of education. Initially offering teaching certificates to the majority population (white), the school evolved to currently serve a predominately minority population (African American). This photographic collection documents the happiness and hurdles stakeholders experienced during the historic eras of Reconstruction, the Industrial Revolution, the Great Migration, the Depression, two world wars, the civil rights movement, and today's information age. Each period provides a backdrop that reveals factors and forces that influenced the normal school's transition from the single purpose of training educators to the all-inclusive goal of offering bachelor's, master's, and doctoral degrees.

Presently, Chicago State University's curricula prepare matriculants for a variety of professions, including school leaders, pharmacists, nurses, and social workers, to name a few. The photographs in this volume span more than a century and a half, revealing experiences, aspirations, and hopes of stakeholders—including this writer—who withstood the social, cultural, emotional, and economic challenges that characterized the times.

—Dr. Sylvia Gist
CSU alumna (1973 and 1976)
CSU professor and dean of College of Education (2008–2013)
executive director of Migration Heritage Foundation (2013 to present)

ACKNOWLEDGMENTS

This book was written in cooperation with many people at Chicago State University. We are grateful for the financial support provided by the Chicago State University Foundation.

This work would not have come to fruition without the support and guidance of Dr. Rachel Lindsey, interim president; Raquel Flores-Clemons, university archivist; Dr. Richard Darga, dean of libraries; Dr. Sylvia Gist, retired dean of College of Education; Dr. Kimberly Black, chair of doctoral studies and information studies departments within the College of Education; Dr. Jamilah R. Jor'dan, interim dean of the College of Education; and Drs. Robert and Marie Szyman, professors of physical education.

Additionally, we thank the following CSU professors, administrators, and staff—and others unafilliated with the school—who assisted in locating images and/or providing context: Dr. Aleshia Terry, Amalia Diaz, Andre Russell, Dr. Andrea Van Duzor, Dr. Angela Henderson, Aremu Mbande, Dr. Athanase Gahungu, Brandon Morgan, Brandon Ruppel, Dr. Carol Schultz, Dr. Chandrasena Cabraal, Dr. Chris Botanga, Corrine F. Grant, Dr. Crystal Laura, Danielle Dewalt, Desiree Montgomery, Dr. Devi Potluri, Dr. Evelyn Delgado-Norris, Dr. Frank McKnight, Dr. Gabriel Gomez, Dr. Garrard McClendon, Matt Raidbard, MaToya Marsh, Dr. Mel Sabella, Dr. Moussa Ayyash, Dr. Nancy Grim Hunter, Dr. Nayshon T. Mosley, Dr. Olanipekun Laosebikan, Dr. Patricia Steinhaus, Dr. Rohan Attele, Roosevelt Martin, Susan Kirt, Tressa Jones, Kathleen Bethel, and Dr. Virginia Shen.

We would also like to acknowledge our colleagues, friends, and families for providing emotional support and enthusiasm for the project.

Finally, we would like to thank Caroline Anderson, our editor at Arcadia Publishing. Without her help, this project would not have been possible.

Unless otherwise noted, all images appear courtesy of the Chicago State University Archives and Special Collections.

INTRODUCTION

Throughout its 150-year history, Chicago State University (CSU) has seen trials and tribulations, and through it all, the word "responsibility," from the school's motto, has been a constant. As the school began to grow and transform from a teacher training school to a four-year university, its changing name reflected its thread of responsibility.

The university started in 1867 in Blue Island, Illinois, under the name Teaching Training School, where students were able to obtain a teaching certificate. In 1869, the Village of Englewood won the bid to include the school within its boundaries, and it became known as Cook County Normal School and was led by Daniel Wentworth (1867–1882). The village offered $25,000 and 20 acres of land. The first building cost $140,000, and it was dedicated on September 21, 1870. During the late 19th century, the school was led by pioneer in progressive education Francis Wayland Parker (1883–1899). Due to financial issues with the county, the City of Chicago took over the school in 1897, and it was named Chicago Normal School. This transition filled a need due to the fact that the city closed its teacher training program approximately 20 years earlier. After Parker passed away, the leadership of the institution was under Arnold Tompkins (1900–1905), who saw the institution through the construction of the Dome Building in 1905, the development of Normal Press, and the introduction of teaching training in Chicago public school classrooms. In 1905, the institution welcomed its first woman principal, Ella Flagg Young (1905–1909), who wanted to change the curriculum to a three-year program but received resistance from the board. During the 1920s, under the administration of William Bishop Owen (1909–1928), the college had numerous extracurricular activities. The Great Depression resulted in the campus being threatened with closure, but students and faculty protested to keep it open. In 1938, the school's name changed to Chicago Teachers College (CTC), reflecting the four-year bachelor of education curriculum. In the same year, a master of education program began, providing graduate studies. From 1928 to 1948, the only way to become an elementary-level teacher in Chicago was to graduate from CTC.

After World War II, the question of who was going to oversee and fund the school was up for dispute. The decision was between city or state control. Dean Raymond Cook (1948–1965) believed that sustaining the institution would only happen with permanent state appropriations. His and others' efforts were successful when, in 1951, Gov. Adlai Stevenson signed House Bill 491, which legalized this. The demographics of the campus changed after the war as soldiers who returned home were given the G.I. Bill of Rights, which, among other things, gave money to veterans specifically to pursue additional education and/or training. Students

who could not previously afford a college education now had an opportunity to do so. As a result, there were more students from the lower and middle socioeconomic classes enrolled. The racial and social composition of the student body changed in the 1950s. Previously, enrollment of African American students was no more than 10 percent. By the end of the 1950s, it was closer to 30 percent.

In 1965, a decision was made to move the campus from Sixty-third Street and Stewart Avenue to another site due to expansion needs. During February 1968, land at Ninety-fifth Street and King Drive was purchased for $8 million; it was the site of Burnside Yards. This location was selected not only for its size, which was large enough to accommodate a growing curriculum and student body, but also its distance from the Chicago Teachers College North Campus (later Illinois Teachers College Chicago North), in the North Park neighborhood. In 1966, the Illinois State Board of Governors of State Colleges and Universities merged Illinois Teachers College Chicago North and all satellite campuses on the north side, forming Northeastern Illinois University (NEIU). The board also determined that Milton B. Byrd (1966–1974) would be appointed president of Illinois Teachers College Chicago South. Due to state mandate, "Teachers College" was removed from all state schools; thus, Illinois Teachers College Chicago South became Chicago State College (CSC). In 1967, due to student demand on the West Side, the administration began to operate a West Campus with undergraduate and graduate offerings.

In 1967, most students were from the south and west sides of Chicago, living within a 10-mile radius of the school, and 65 percent were African American, working-class, and first-generation students. Almost all were employed either part-time or full-time in order to support their education and families. Students were willing to invest their time and money in CSC because they wanted to qualify for higher paying jobs. Although the education curriculum was still a draw to bring students to CSC, students were also exploring other career options, such as in the radio and television business. In 1969, the college partnered with local radio station WVON to host an event called Fourth Estate 1969, which brought disc jockeys Roy Wood and Wesley South to campus to explain to the predominately black student body the importance of having diverse media representation.

In 1971, Chicago State College became Chicago State University (CSU), and in 1972, it completed its move to the new campus. In 1974, CSU had its first black president, Dr. Benjamin Alexander (1974–1982). Under his leadership, the previous academic divisions from the old Chicago State College structure became the College of Arts and Sciences and the College of Education. Two colleges were added—nursing and business administration—and in 1977, a new College of Allied Health was approved by the Board of Governors and the Illinois State Board of Higher Education. President Alexander and the students sought Pres. Gerald Ford to speak at the 1975 commencement. At first, President Ford declined due to a very busy schedule. However, with the help of Illinois senators and 5,000 student signatures, he agreed to speak. Also in 1975, the Reserve Officers' Training Corps (ROTC) came to campus via an agreement with the University of Illinois at Chicago (UIC), and due to student interest in 1982, the university had its own program. Additionally, in 1975, CSU hired Dorothy Richey, who was the first woman in the United States to be an athletic director at a co-ed university.

Throughout the 1970s and 1980s, the student enrollment remained steady and diversified, which brought opportunities for new types of courses, speakers, and activities. President Alexander did not want CSU to become a "school for black students only" and worked to increase the diversity of the students and staff. This is clearly shown in the inclusion of Black History Month (February) and Latino Heritage Month (September–October) activities. Black History Month had activities such as fashion shows, Greek step shows, talent shows, lectures, workshops, and concerts. In 1972, the Latin-American Student Association was formed, and in 1985 changed its name to the Organization of Latin American Students (OLAS). Due to its efforts as well as input from the Hispanic community, in 1988 the Office of Hispanic American Affairs under the offices of provost and vice president for academic affairs was

established. This office was charged with assisting to recruit and retain Hispanic students and faculty. Currently, the University has the Latino Resource Center under the Department of Student Affairs and several student organizations for Hispanic and Latino/a American students. These offices and organizations were created to support the growing population of Spanish-speaking students through mentoring, tutoring, scholarship opportunities, cultural activities, and outreach initiatives for Latino/a students on campus and the surrounding areas. As part of its community outreach and effort to expose students to people of influence, CSU hosted a variety of local, national, and international scholars, actors, dignitaries, performers, and athletes on campus, such as actors Ted Lange, Mr. T., and psychologist Na'im Akbar. Following Alexander, in 1982, was George Ayers (1982–1989), who continued to expand CSU's influence and collaborative partners by inviting visitors from countries such as Germany and establishing a foreign exchange program with the University of Liberia.

The 1990s was a time of tremendous growth and development on campus, which was completed under the leadership of the university's first African American woman president, Dr. Delores Cross (1990–1997). Dr. Cross was also the first woman to head a four-year public university in the state of Illinois. Due to her vision to increase the arts and literature on campus, Pulitzer Prize–winning poet Gwendolyn Brooks was hired in 1990 as a distinguished professor in English, and a literary center was named after her. This center served as the model for the Center for Black Literature at Medgar Evers College, City University of New York. In 1992, CSU celebrated its 125th anniversary. One part of this celebration was the first annual Conference on Black Literature and Creative Writing. Under the helm of poet, publisher, CSU professor, and center director Haki Madhubuti, the conference not only presented scholarly and artistic writings on black literature, but also celebrated the accomplishments of Gwendolyn Brooks. Madhubuti also helped to create the master of fine arts degree, established in 2001, which was one of the first programs in the country to center on the writings of black/African Diaspora writers.

By 1991, CSU's television production department, as well as its radio station WCSU, was fully developed and running. The CSU Jazz Fest began in 1991. Initially, the university's jazz bands performed. By 1992, professional and high school groups joined the university bands. As part of a $23 million renovation project, two buildings were constructed, a 500-bed residence hall and a new student union. Even though CSU is primarily a commuter campus, the university wanted to offer a residence hall experience for its students. With the increase of international students, the residence hall offered a place to live. The student union provided a cafeteria, meeting rooms, and communal areas for students and faculty. It was renamed the Cordell Reed Student Union in 2001.

As CSU entered the 21st century, it continued to progress and keep up with the needs of the community. In 2005, a new library, the New Academic Library, was built and houses the first automatic retrieval system in the state. It is home to the Learning Assistance Center (LAC), the Honors College at Chicago State University, Center for Teaching and Research Excellence (CTRE), and the Department of Archives, Records Management, and Special Collections (ARMS). In 2017, this building was dedicated and renamed the Gwendolyn Brooks Library. In 2005 and 2007, the first cohort of students were admitted to the doctorate of education program and doctorate of pharmacy program, respectively. The Emil and Patricia A. Jones Convocation Center, which cost $38 million, opened in 2007. Emil Jones Jr. was an Illinois state representative and senator who has been a strong supporter of CSU. His late wife, Patricia, was a graduate of CSU. Until this time, CSU either needed to go off campus for its commencement ceremonies or hold them outside, and Jones felt that CSU needed its own venue. Additionally, the center serves as the arena for men's and women's basketball and citywide tournaments and is a location for community/campus programs and concerts.

Dr. Elnora Daniel (1998–2008) with a background in nursing, oversaw CSU's expansion into STEM and health sciences. CSU earned many sponsored grants and donations to fund its cutting-edge education and STEM programs. Examples include the Teacher Quality

Enhancement Grant Middle School Project and the Center for STEM Education & Research, both funded by the US Department of Education; the Center for Information and Security Education & Research, funded by the US Department of Defense; and the National Institute of General Medical Sciences. In 2000, Daniel started the South Africa Area Initiative (SAAI) to address the critical education needs of the country and to create connections between CSU and three universities that have been selected as historically disadvantaged.

In 2009, the CSU board of trustees selected Dr. Wayne Watson (2009–2016) as the president of the university. Students and faculty questioned the presidential selection process and met this announcement with protests and concerns, which went unheeded by state politicians. During his administration, Watson created the Jazz in the Grazz concert series, oversaw the effort to move CSU athletics to the Western Athletic Conference (WAC), and led the effort to bring the Barack Obama Presidential Center to CSU, which ultimately was awarded to the University of Chicago. Additionally, under his tenure, the University Archives and Special Collections acquired several archival collections. For two years, the Illinois legislature did not pass a state budget, which affected all state agencies including institutions of higher education. This resulted in an uncertain time for the university as well as the other state agencies. Rallies and demonstrations were held across the state in order to pressure legislators to pass funding. CSU students, faculty, and administrators participated in several of these events, and a few were organized on campus. The university's administration and student body sought ways to fundraise. In January 2016, Dr. Thomas Calhoun (2016–2016) became the president of the university with a vision to increase student enrollment and to fix the budget crisis that hit the university. Due to unforeseen circumstances his tenure was short, and for a year the university was under the leadership of Dr. Rachel Lindsey (2017–2018), who served as interim and is the former dean of arts and sciences. In May 2018, the CSU board of trustees announced that Zaldwaynaka "Z" Scott would become the next president of the university.

There are now five colleges and one division. The Colleges of Education, Arts and Sciences, Business, Health Sciences, and Pharmacy offer 36 undergraduate, 22 master, and two doctoral degrees, doctorate of education in educational leadership and doctorate of pharmacy. The Division of Continuing Education and Nontraditional Programs offers extension courses, distance learning, and not-for-credit courses. This division offers a baccalaureate degree through the Individualized Curriculum Program. In addition, CSU has an honors college for undergraduate students of all majors.

A university such as CSU has many illustrious alumnae, including teachers, writers, performers, athletes, scholars, scientists, artists, and several others. They have taken on the motto of the university, responsibility, in each of their arenas. For 150 years, CSU has had an influential and important impact on the lives of many. Some were students, while others visited the university for programs, summer camps, or swim lessons, or were children in the daycare center. From its humble beginnings as a teacher training school, it has become a nationally recognized university. In the following pages you will find highlights of the university and its many roles in the community.

One

WHAT IS TAUGHT

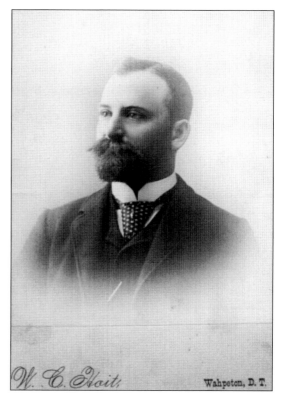

This photograph of Herbert Baldwin, taken in 1877, is one of the oldest photographs in the Chicago State University Archives and Special Collections. By the time Baldwin graduated, teaching had become more professional, requiring a certification examination and advanced education.

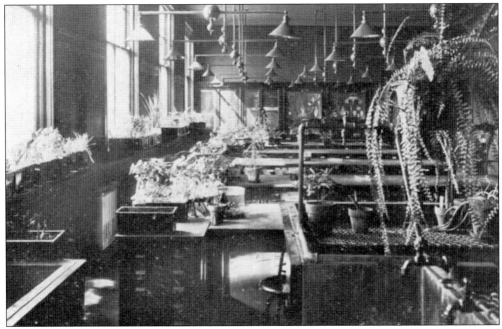

Principal Ella Flagg Young originally started as a teacher for the college. She envisioned Chicago Normal School becoming a college, where students could finish their degrees in evening classes while they taught during the day. She believed that part of a college education included understanding science. Laboratories were added to the renovated Dome Building in 1912.

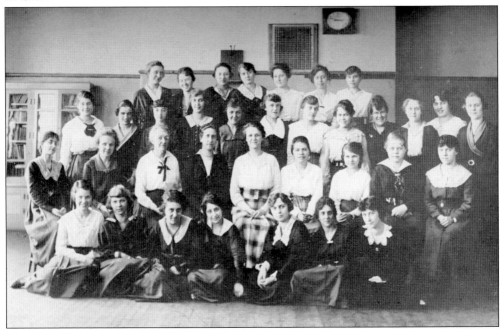

Students in the household arts department learned everything from running a school cafeteria to working with communities on food distribution and management. During World War I, students worked with the Red Cross to make clothing for children in Belgium.

By 1938, Chicago Normal College had an upper division, lower division, and college graduates. With clubs like the *Emblem* (yearbook), *Normalite* (newspaper), student council, and athletic teams, there were many activities for students outside of their lessons and practice teaching. In this photograph, alumni from the class of 1938 meet in the spring of 1975 during their 36th reunion.

Chicago Teachers College alumna (class of 1937), artist, educator, and co-founder of the DuSable Museum of African American History, Margaret Burroughs is pictured holding her signature linocut drawings. In the late 1960s, she worked with the Chicago State College Oral History Research Project to conduct oral histories with prominent figures. The collection is now housed within the university's archives. Burroughs was awarded a Distinguished Alumni Award by the university in 1984. She died in 2010.

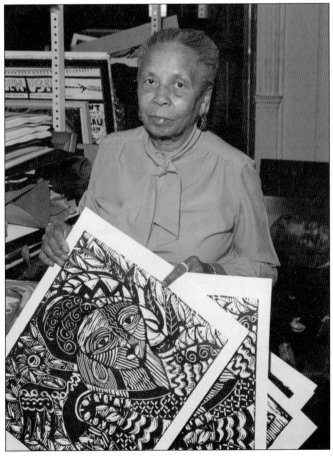

Mamie Till-Mobley, seen in this yearbook photograph, graduated from Chicago Teachers College in 1960. She was an educator, civil rights activist, and public speaker. Most of the world knows her as the mother of Emmett Till, whose racially charged murder led civil rights activists to protest the violence toward African Americans. She was a public schoolteacher for over 20 years. During this time, she became an advocate for children living in poverty.

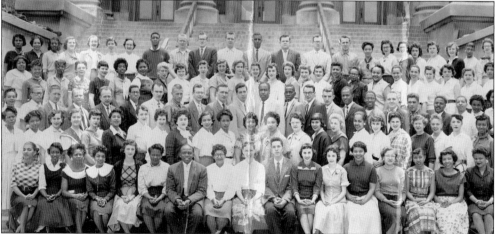

During the late 1950s and early 1960s, the demographics of the student body were changing from predominately white to African American. This class photograph of graduates from the class of 1958 shows this shift. In the coming years, the college would see a curriculum and political shift.

Human physiology class was one of many required courses for students who wanted to be science teachers. Esther Da Costa, a professor in the biological sciences department, is giving a lecture to her students.

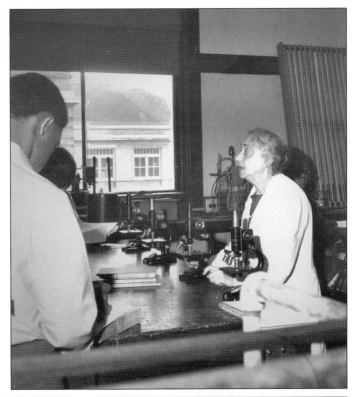

Two young ladies review the resources at the campus library for materials for their social sciences course. Note the labels on the shelves for the Dewey Decimal classification system. Learning the system allowed students to be more independent researchers. Encyclopedias were the main reference source before the Internet.

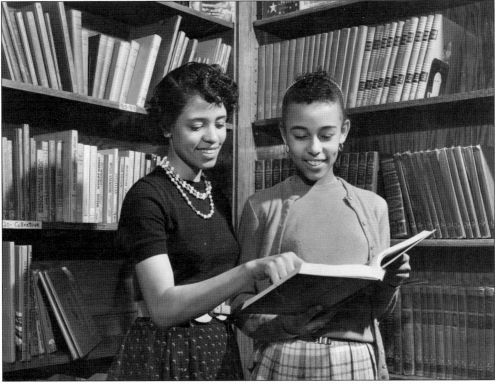

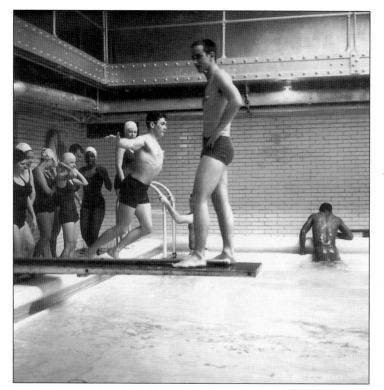

Chicago Teachers College encouraged peer teaching as part of its curriculum. Pictured in the spring of 1968, Bob Szyman, on the diving board, is instructing his classmates in a water safety class. Jumping from the swimming pool ledge is classmate Paul Rothengras. The students are training for lifeguard certification. (Courtesy of Robert and Marie Szyman.)

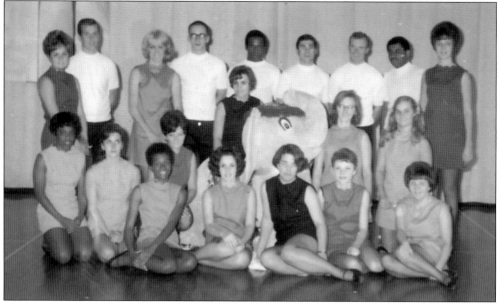

Pictured here is the class of 1969 physical education cohort. Listed in alphabetical order are Annette Esposito, Bob Szyman, Cindy Bryja, Darlene Munto, Glandine Thompson, Jacques Cosey, Jesse Fields, Jim Carlson, Joanne Musial, John Burke, Linda Bennett, Linda Pomykalaski, Lorraine Pink, Marilyn Ludwig, Nancy Novak, Pat Kolacki, and Paul Rothengras. The stuffed elephant in the center is there because the jump routine in their gym show, "Mission Impossible," was done to the song "Baby Elephant Walk." (Courtesy of Robert and Marie Szyman.)

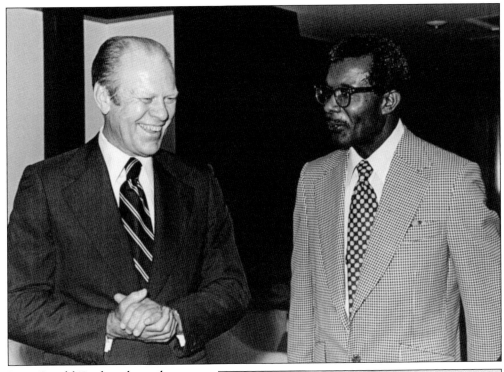

Pres. Gerald Ford spoke at the 292nd commencement (1975). He is pictured here with Dr. Benjamin Alexander, university president. At that time, the university did not have a convocation center. In 1975, commencement was held at the Arie Crown Theater. At the ceremony, Ford was presented with an honorary doctor of laws degree. Ford came to CSU after receiving a 45-foot scroll with over 5,000 signatures from CSU students. In his speech he stated, "CSU serves the urban needs of a great city. Not long ago CSU came under heavy attack. But you effectively answered the challenge . . . You have overcome."

THE WHITE HOUSE
WASHINGTON

July 25, 1975

Dear Dr. Alexander:

It is difficult to thank you and Mrs. Alexander adequately for your warm welcome and friend-ly hospitality during our visit to Chicago State University on July 12. We were especially pleased to be present for the graduation exer-cises, and I was deeply honored to be awarded the Honorary Degree of Doctor of Laws on this occasion. The hood which you so thought-fully presented to me will always serve as a reminder not only of this special recognition but of your thoughtfulness as well.

You and Mrs. Alexander were very kind to remember my birthday, and your greetings helped to make July 14 a very happy day for me. Mrs. Ford joins me in sending our sincere thanks and warmest personal regards to you and Mrs. Alexander.

Sincerely,

Jerry Ford

Dr. Benjamin H. Alexander
President
Chicago State University
Ninety-Fifth Street at King Drive
Chicago, Illinois 60628

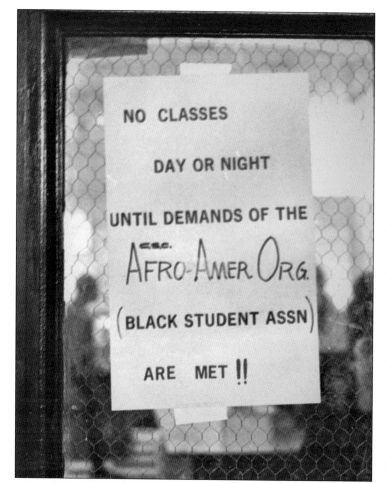

Due to student interest and demands, the college created a Black Studies concentration and hired more black faculty. The offering of a concentration in black studies was a direct result of student petition, demands, and some physical altercations, which resulted in a partial shutdown of campus, as seen in these photographs from 1969. Chicago State College's implementation of this change mirrors what was happening across the country in other colleges and universities.

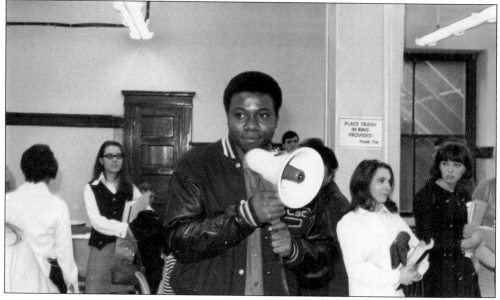

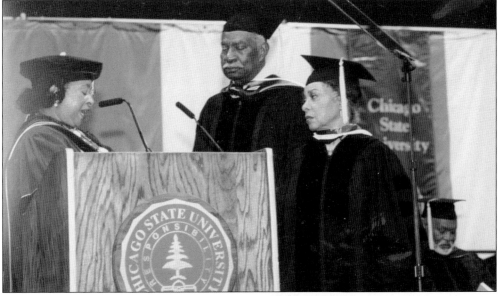

In 2002, actors Ossie Davis and Ruby Dee were honored with honorary doctorates from CSU. Dr. Elnora Daniel was the second African American woman to be president of the university. That ceremony was held at the University of Illinois at Chicago Pavilion. Ossie Davis is known for his work in *Do the Right Thing* (1989) and *Jungle Fever* (1991); Ruby Dee is known for her work in Chicago playwright Lorraine Hansberry's *A Raisin in the Sun* (1961). Both are known for their activism against social injustices in the United States. (Right, courtesy of Byung-In Seo.)

From 2000 to 2007, CSU earned the Teacher Quality Enhancement Grant Middle School Project. This grant was funded by the US Department of Education, with matching funds from the Illinois Board of Higher Education, in partnership with the Illinois Community College Board and the Illinois State Board of Education. Dr. Nancy Grim Hunter (far right) is working with students of the middle school cohort. Grim Hunter led the statewide initiative to develop the associate of arts in teaching science degree.

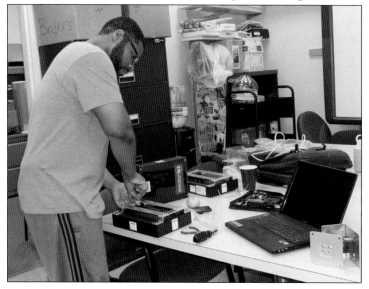

Frederick Williams is an international studies major with a security and intelligence minor. Here, he is assembling a real-time location system for a project for Dr. Moussa Ayyash. After much effort, he got the machine to work. (Courtesy of Kimberly Black.)

In 2009, Angela Roberts-Watkins was the first recipient of the doctorate of education in educational leadership. Pictured are, from left to right, (first row) Nancy Grim Hunter, associate dean of College of Education; unidentified dissertation committee member; Sylvia Gist, dean of College of Education; Angela Roberts-Watkins; and Norma Salazar, chair of the Department of Educational Leadership, Curriculum, and Foundations; (second row) Leon Hendricks, Athanase Gahungu, and Emmitt Bradley. (Courtesy of Athanase Gahungu.)

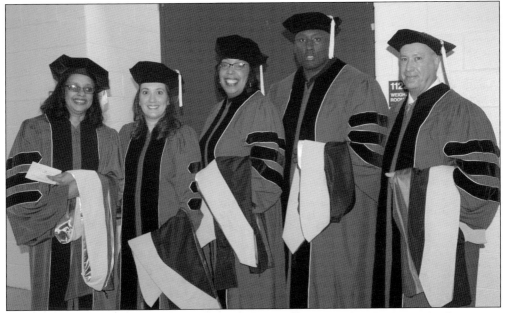

In 2005, CSU started its first doctoral program, which was in educational leadership. Every fall, one cohort of 5 to 15 students is admitted. Students in each cohort begin and complete their core courses at the same time. This photograph is of graduates from the fall of 2013. From left to right are Alice Penammon (Cohort 1), Fotini Bakopoulis (Cohort 2), Tracy Cureton (Cohort 2), Lawrence Willis (Cohort 1), and Jimmy Gunnell (Cohort 3). (Courtesy of Byung-In Seo.)

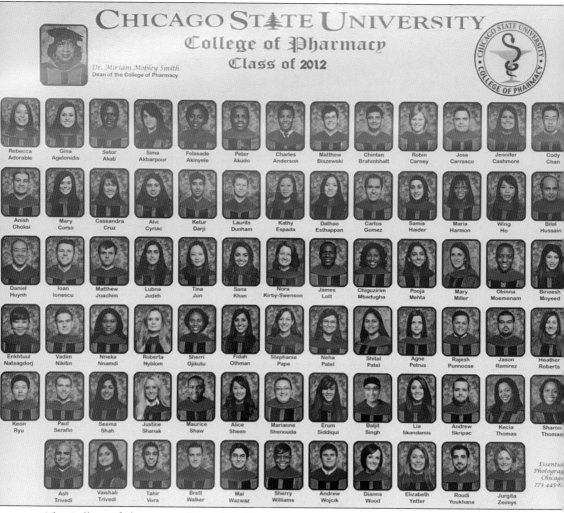

CHICAGO STATE UNIVERSITY
College of Pharmacy
Class of 2012

Dr. Miriam Mobley Smith
Dean of the College of Pharmacy

Rebecca Adorable	Gina Agelonidis	Setor Akati	Sima Akbarpour
Folasade Akinyele	Peter Akudo	Charles Anderson	Matthew Biszewski
Chintan Brahmbhatt	Robin Carney	Jose Carrasco	Jennifer Cashmore
Cody Chan			

Anish Choksi, Mary Corso, Cassandra Cruz, Alvi Cyriac, Ketur Darji, Laurits Dunham, Kathy Espada, Dathao Esthappan, Carlos Gomez, Samia Haider, Maria Harmon, Wing Ho, Bilal Hussain

Daniel Huynh, Ioan Ionescu, Matthew Joachim, Lubna Judeh, Tina Jun, Sana Khan, Nora Kirby-Swenson, James Lott, Chigozirim Mbadugha, Pooja Mehta, Mary Miller, Obinna Moemenam, Bineesh Moyeed

Enkhtuul Natsagdorj, Vadim Nikitin, Nneka Nnamdi, Roberta Nyblom, Sherri Ojikutu, Fidah Othman, Stephanie Pape, Neha Patel, Shital Patel, Agne Petrus, Rajesh Punnoose, Jason Ramirez, Heather Roberts

Keon Ryu, Paul Serafin, Seema Shah, Justine Shanak, Maurice Shaw, Alice Sheen, Marianne Shenouda, Erum Siddiqui, Baljit Singh, Lia Skandamis, Andrew Skripac, Kecia Thomas, Sharon Thomas

Ash Trivedi, Vaishali Trivedi, Tahir Vora, Brett Walker, Mai Wazwaz, Sherry Williams, Andrew Wojcik, Dianna Wood, Elizabeth Yetter, Roudi Youkhana, Jurgita Zeimys

Essentia Photogra Chicago 773 445-8.

The College of Pharmacy admitted its first group of students in the fall of 2007. CSU's program has an integrated curriculum, combining science and practice in pharmacy to provide care for a global community. Students do rotations all over the world. Since its inception, the program was intentionally designed to attract a diverse population. It has been named a top-10 school in the nation for diversity, as illustrated in this photograph of the first graduating class in 2012. (Courtesy of Amalia Diaz.)

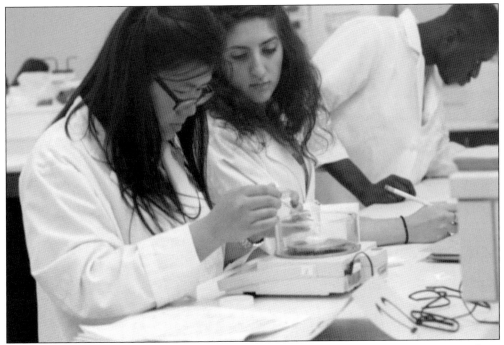

Students in the pharmacy program learn cutting-edge techniques to integrate their understanding of drugs, actions, structures, and therapeutics. To learn how to compound and make medications, CSU pharmacy students take a class in dosage forms, as seen here.

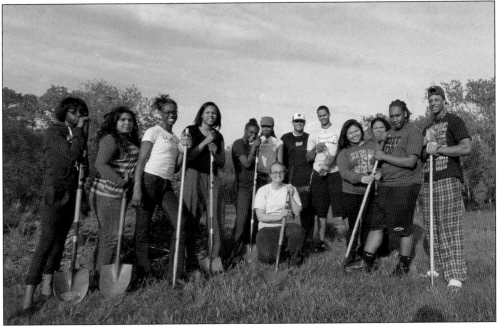

Gone are the days when science is only learned inside a laboratory. Here, a group of biology students poses after a long day of preparing the Prairie Garden for the spring. The Prairie Garden and Bird Habitat for Teaching and Research is a section of the campus where students learn through hands-on experiences with flora and fauna. (Courtesy of Susan Kirt.)

Nicole Oliviel, a senior biology major, is working with Dr. Botanga on the cell wall biosynthetic genes of wheat. (Courtesy of Chris Botanga.)

Each fall, botanists collect seeds in order to preserve the species. Once seeds are collected, they need to be sorted and organized. In this photograph, students are sorting collected seeds from the Prairie Garden. CSU keeps the seeds for studying and propagating future plants. (Courtesy of Susan Kirt.)

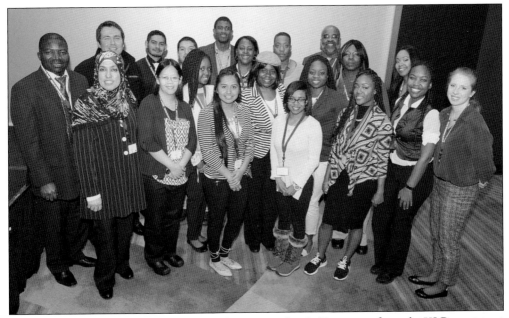

The Center for STEM Education & Research (CSER) is funded by a grant from the US Department of Education and houses other federally funded programs, such as the Illinois Louis Stokes Alliance for Minority Participation (ILSAMP) and the Louis Stokes Midwest Center of Excellence, both funded by the National Science Foundation. CSER and all affiliated programs aim to increase the quality and quantity of underrepresented minority students graduating and pursuing a career or matriculating into graduate programs in science, technology, engineering, and mathematics (STEM). Pictured here are students and faculty who attended the 2017 ILSAMP Conference in Rosemont, Illinois. (Courtesy of Chris Botanga.)

Honoring students who have excelled academically has always been part of CSU's history. At the honors college's 2016 convocation are, from left to right, Ronald "Kwesi" Harris, who was the director of the African American Male Resource Center and founder of Teaching and Educating Black Men of Origin (TEMBO); CSU honors student and student government association member Darren Martin; and dean of the Honors College at Chicago State University Dr. Omar Headen. Harris was inducted as an honorary member of the honors college at this ceremony.

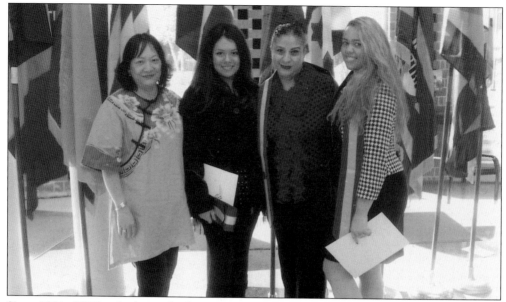

Since 2001, CSU has had a study abroad office. In the Department of Foreign Languages and Literatures, the first program was established with the Universidad de Castilla-La Mancha in Toledo, Spain. In 2013, Karen Gonzalez, Ada Ramirez, and Katrina Santiago spent a month in Spain. After their trip, they, along with the other study abroad participants, received a sash that represented their country's flag and a certificate of participation. (Courtesy of Virginia Shen.)

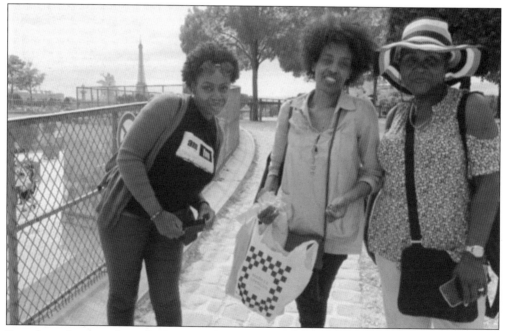

French students study at the Université Internationale d'Eté in Nice, France. In addition to field trips sponsored by the host university, CSU students also studied the black history of the region. From left to right are Biance Alebiosu, Jewel Minor, and Leonetta Dunn on a field trip to Paris. (Courtesy of Evelyn Delgado-Norris.)

28

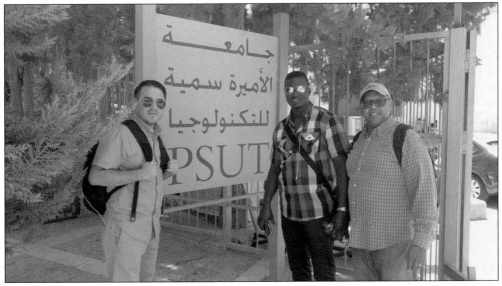

In summer of 2017, students (from left to right) Emmanuel Bustamante, Banmangbale Fargou, and Michael Johnson traveled to Amman, Jordan. There, they studied Arabic and Jordanian culture at Princess Sumaya University of Technology. In this photograph, they are in front of the university sign. (Courtesy of CINSER at CSU.)

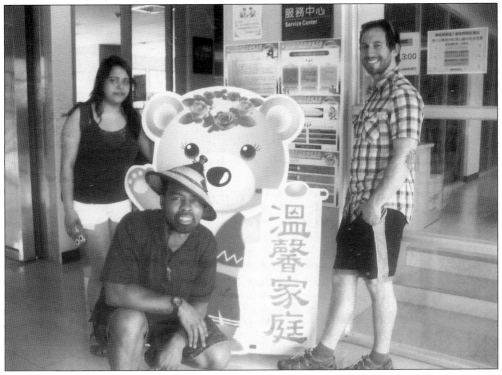

In this 2013 photograph, from left to right, Janet Lopez, Lawrence Cade, and Mitchell Kristie are posing in the lobby of their dormitory. The sign, written in Chinese calligraphy, reads, "Home sweet home," as a welcome to the students. They traveled to Taiwan to study its language and culture. (Courtesy of Virginia Shen.)

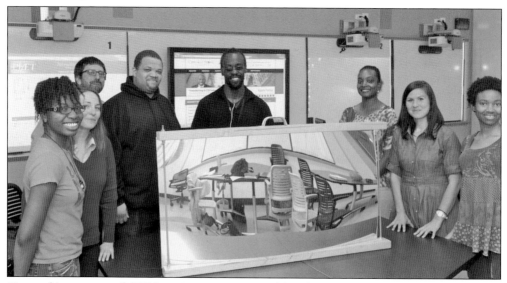

Pictured is a group of CSU learning assistants and faculty coordinators participating in the learning assistant pedagogy course. The CSU Learning Assistant program leverages the expertise of CSU STEM majors to create active learning environments. Here, Ruth Osborne, Jennie Passehl, Dr. Mel Sabella, Louis Issac, Mike Tyler, Brandee Stanton, Kara Young, and Aliyyah Hetherington pose behind a curved mirror, which presents an interesting view of CSU's state-of-the-art classroom.

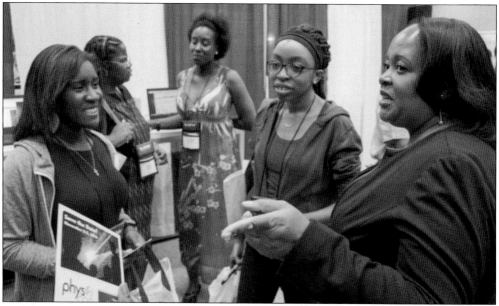

From left to right, Felicia Davenport and Nicolette Sanders talk to Tiffany Hayes, the director of programs and conferences of the American Association of Physics Teachers (AAPT). Davenport and Sanders presented their research at the 2016 AAPT summer meeting in Sacramento, California, on the CSU Learning Assistant program and the CSU Chi Sci Scholars program. In the background are alumni Angela Moore and Dr. Geraldine Cochran chatting about life at CSU. Moore gave an invited talk on physicists with disabilities at this conference. Cochran is a professor at Rutgers University. (Courtesy of Mel Sabella.)

From left to right, Tasha Williams, Jeremy Webb, Anthony Pitts McCoy, and Kiara Fenner present their research at the 2015 LSAMP Spring Symposium at the Tinley Park Convention Center. The spring symposia in STEM, supported by the ILSAMP Program and the CSU Center for STEM Education and Research, have been a long tradition at CSU. (Courtesy of Mel Sabella.)

Jennie Passehl (left) and Ruth Osborne use a motion sensor to analyze the motion of a ball. Passehl worked with CSU as a collaborator in developing and implementing the Learning Assistant program. This program leverages the expertise of CSU STEM majors to create active learning environments. Ruth was one of the learning assistants. This program has grown from three students in a single discipline to about 20 students in six disciplines.

As part of the doctorate of education program, students can earn their superintendent's endorsement on their administrative licensure. This endorsement requires 200 hours of field work under the supervision of a superintendent. CSU students complete their field requirements all over the state, such as at Cahokia Unit School District No. 187 in rural Illinois. Superintendent Art Ryan and assistant superintendent of instruction Tanya Mitchell are flanked by students Devon Horton (left) and Marcus Wright. (Courtesy of Tanya Mitchell.)

International students met with CSU president Dr. Thomas Calhoun in August 2016. The students, pictured here, were primarily from Andhra Pradesh and Telangana states in southeast India. Many of them majored in computer science and mathematics. (Courtesy of Richard Darga.)

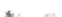

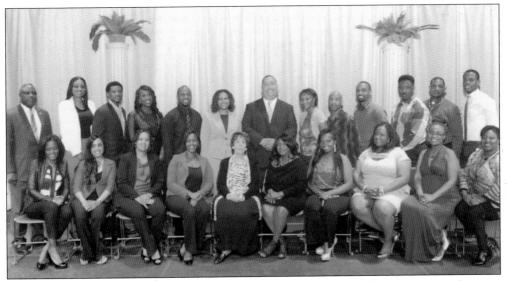

The College of Business is an urban-based learning center where students prepare to become leaders in the local, state, and global arenas. Since CSU graduates have to interact with other members of society, adapt to societal changes, and serve as business advocates, students are encouraged to study global topics that will prepare them for these challenges in the ever-changing society. Every year, a reception is held to celebrate the graduates. This photograph is of graduates from the spring of 2014 cohort. (Courtesy of Roosevelt Martin.)

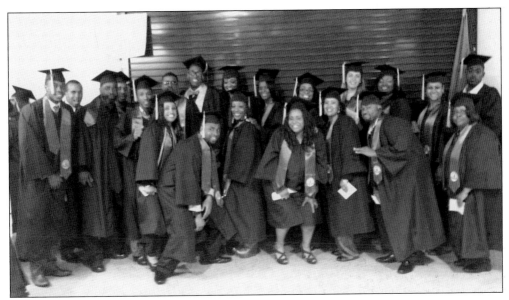

A small portion of the spring of 2014 cohort is pictured at the commencement ceremony. (Courtesy of Roosevelt Martin.)

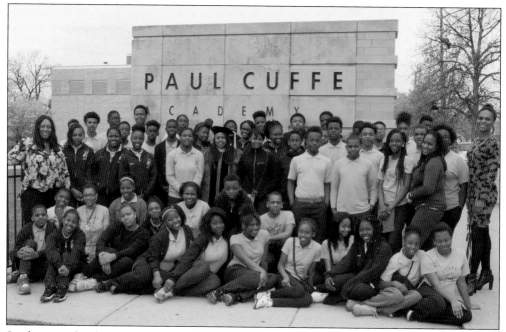

Students in the doctorate of education program are movers and shakers in the educational world in Chicago. Most are accomplished educators and administrators in their own right. Pictured here are Lakita Reed (at center in cap and gown), principal of Paul Cuffe Science and Math Academy in Chicago; eighth-grade teachers; and students. When Reed graduated, her eighth-grade class came to the hooding ceremony. (Courtesy of Byung-In Seo.)

When a cohort begins, all students take their coursework and qualifying examinations together. Once they pass their exams, they proceed to doctoral candidacy and the dissertation stage. Depending on the students' research topics and methodologies, completing the dissertation phase can take as little as 12 months or as much as four years. In this photograph, Cohort 5 celebrates Howard Coleman's (seated second from right) success as the first to graduate from his cohort. He completed his dissertation in 18 months. (Courtesy of Byung-In Seo.)

The Center for Information and Security Education & Research (CINSER) was formed in 2016 with grants from the National Security Agency and the National Science Foundation. On August 11, 2017, CINSER concluded its first GenCyber@CSU Camp for Teachers. On the far left is Dr. Moussa Ayyash, director of CINSER; he is helping GenCyber 2017 participants. (Courtesy of Danielle Dewalt.)

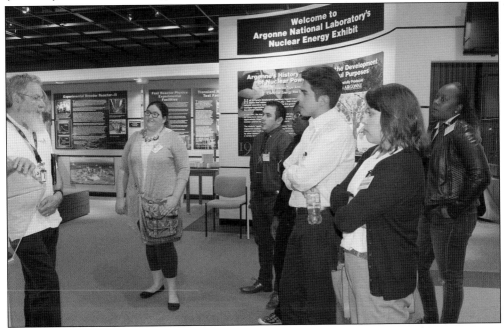

On April 18, 2017, CINSER sponsored its second Spring 2017 Security and Intelligence Roundtable Discussions at Argonne National Laboratory (ANL). Taking a tour of the museum with ANL staff are Victoria Breshears, Michelle Sanders, Victor Hurtado, and Janet Lopez. (Courtesy of Danielle Dewalt.)

Aleshia Terry, executive assistant to the provost, and Frank McKnight, director of academic support/academic advising, pose before their commencement ceremony. Both earned their doctorate of education in educational leadership from CSU. They were both part of Cohort 5. (Courtesy of Byung-In Seo.)

Two

ACTIVITIES AFTER CLASSES

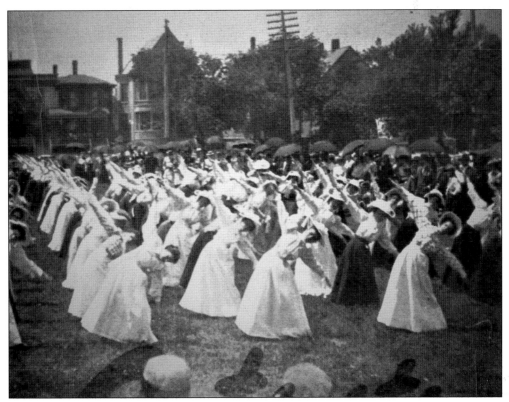

May Day is traditionally celebrated on May 1 to mark the onset of spring with songs, dances, and food. This photograph shows the annual May Day Pageant, an event that the community looked forward to each year.

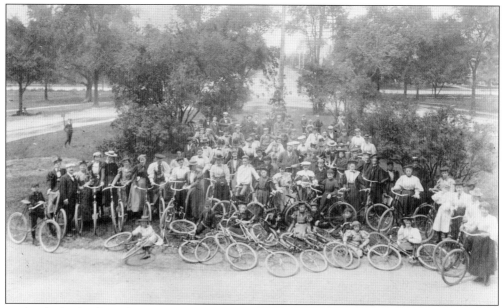

Under the leadership of principal Dr. William Bishop Owen, the physical health of the students and their academic course selection became more important. Before automobiles, there were three ways to get around in Chicago: public transportation, bicycles, or walking. Many young adults chose riding their bicycles because it gave them the freedom to get from one place to another quickly. These students display their bicycles on the front lawn of the school.

During both World War I and World War II, students and faculty from the household arts and sciences department worked with the Red Cross to help with the war efforts. They took on a variety of activities such as making clothes for children in war-torn countries, collecting and rolling bandages, and providing care packages to the soldiers overseas. Students were encouraged to take what they learned at the college and start supportive efforts in their own neighborhoods.

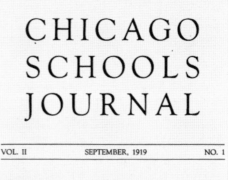

Chicago State University has been home to many publications. The *Chicago Schools Journal*, pictured at right, started as *The Educational Bi-Monthly* and is today's *Illinois School Journal*, which provides educators with information on best practices and curriculum trends. The other publications the institution has been known for are its yearbook, which had several names—*Emblem, Seniorian* (1932), *Graduate* (1978), and *Reflections* (1979–1984); and the student newspaper the *Normalite*, which changed its name to the *Tempo* in 1938 (below).

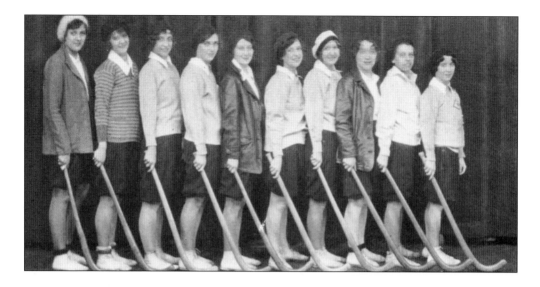

Chicago Normal College students participated in physical education and team sports. Membership on these teams conferred status. In the 1920s, the institution offered students a robust variety of sports as part of the curriculum. In a 1917 issue of the *Progressive Teacher and Southwestern School Journal*, the institution advertised its courses for physical education for women. Pictured here are the women's field hockey and baseball teams from 1930.

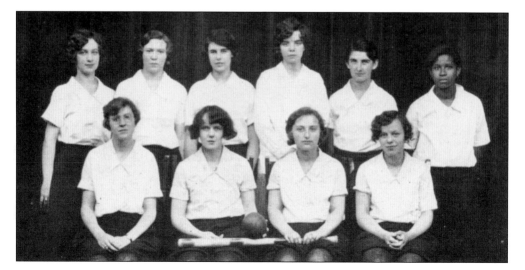

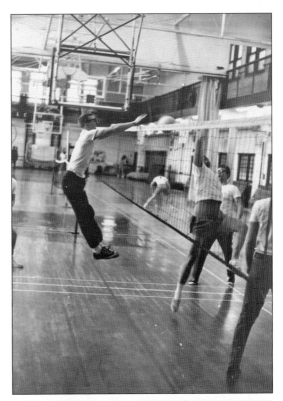

From its founding, physical education was seen as a vital part of an academic institution. The school offered both intramural and collegiate sports including wrestling, hockey, bowling, judo, swimming, baseball, soccer, softball, basketball, volleyball, and track and field. These photographs show intramural volleyball games. Intercollegiate athletes play for trophies, while intramural teams play for pride.

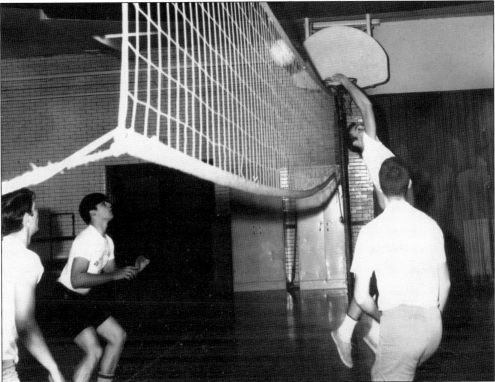

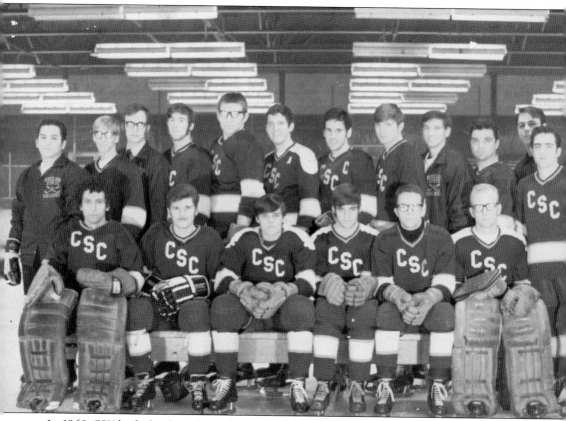

In 1969, CSU had a hockey club, which eventually became a varsity team. The coach was Bob Szyman, a graduate student and teaching assistant in the physical education department. The goalie seated at left in this photograph is John Panozzo. He, along with his brother Chuck, Dennis DeYoung, and Tom Nardin, formed the band TW4. They played at fraternity parties and high schools while studying to become teachers at Chicago State College. By 1972, they were discovered by Wooden Nickel Records and changed their name to Styx. The band had several hits during the late 1970s and into the 1980s. (Courtesy of Robert and Marie Szyman.)

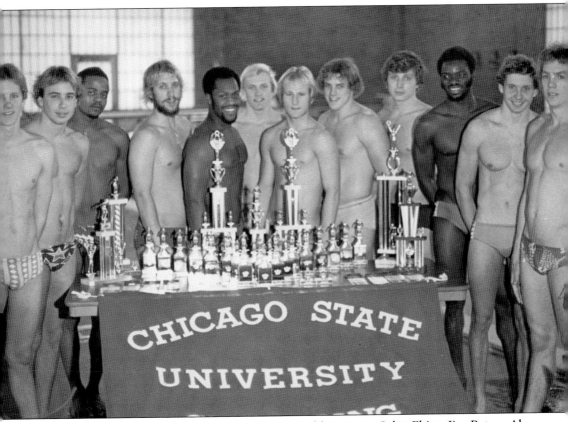

The 1976–1977 CSU swim team consisted of Donald Bennett, John Ebito, Jim Baton, Al Kickert (co-captain), Fred Evans, Mike Puhl (co-captain), Dave Prosken, Ed Thompson, Wayne Welchko, Dan Prosken, Gene Sardzinski, Frank Levanovic, John Lozano, and Bill Brown. Evans was the first African American athlete to win a National Association of Intercollegiate Athletics (NAIA) championship, in April 1975 in the 100-yard breaststroke. He held the national record for the same event from 1975 to 1977.

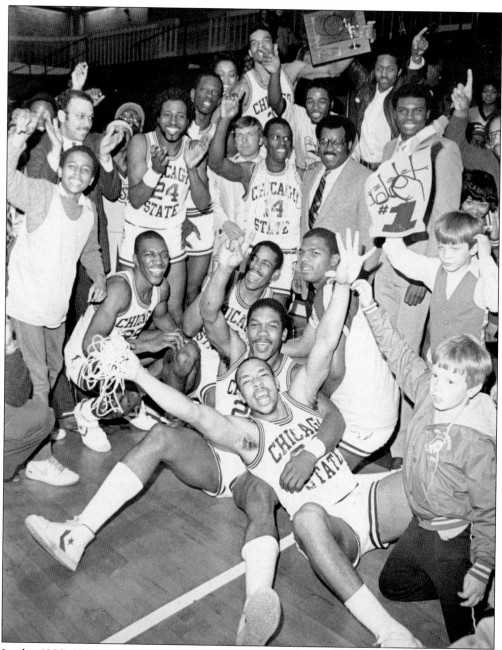

In the 1982–1983 season, the CSU basketball team was number one in the NAIA. In this photograph, they are celebrating with their trophy and the net. Player Sherrod Arnold made the NAIA All-American Team. Coach Bob Hallberg was named District Coach of the Year.

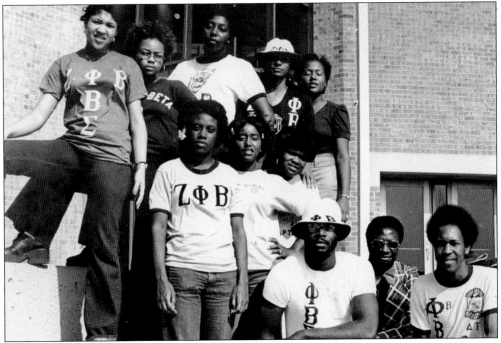

Pictured are members of the National Pan-Hellenic Council on campus. The mid-1970s and 1980s saw an influx of black Greek fraternities and sororities, including Kappa Alpha Psi (1974), Sigma Gamma Rho, Alpha Phi Alpha (1977), Delta Sigma Theta, Phi Beta Sigma (1985), Zeta Phi Beta (1985), Omega Psi Phi, Alpha Kappa Alpha, Beta Phi Pi, and Phi Rho Eta. All of them host campus programs as well as dedicating themselves to community service.

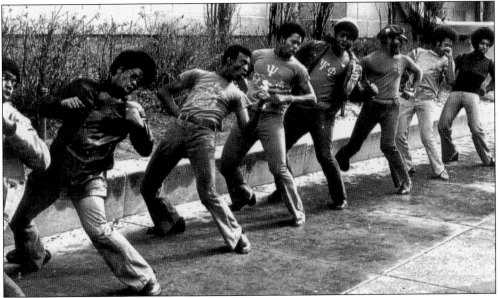

Here are members of Omega Psi Phi stepping on the Chicago State College campus. A hallmark tradition of black Greek life is stepping, a form of dance that can be traced to Africa. The organizations of the National Pan-Hellenic Council have used stepping to show pride in their heritage and to uplift audiences.

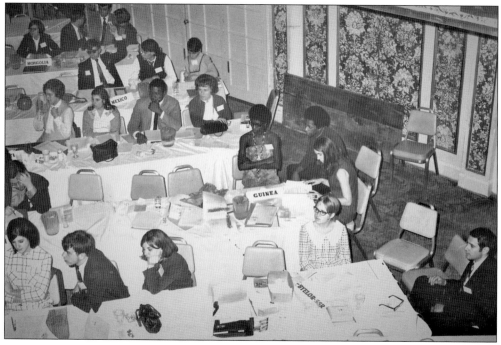

Chicago State College delegates are pictured at the Midwest Model United Nations (MMUN) in 1969. The MMUN brought together college students from across the Midwest. The CSC program was run by Dr. Robert Kovarick, who was the undergraduate advisor in the history and political science department. In 1973, the Chicago Model United Nations was established to provide CSU and Chicago area high school students the opportunity to connect and learn about geopolitics. Additionally, it served as a recruiting tool for the university.

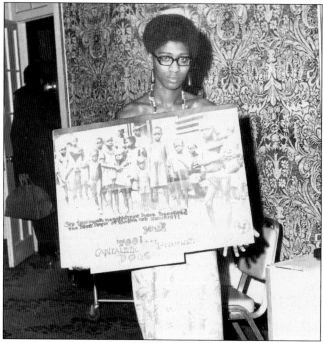

At the MMUN, Ivy Dise gave a presentation on the Republic of Biafra. Biafra was an unrecognized country that seceded from Nigeria in 1967. In addition to this presentation, Dise was a member of the Guinea delegation.

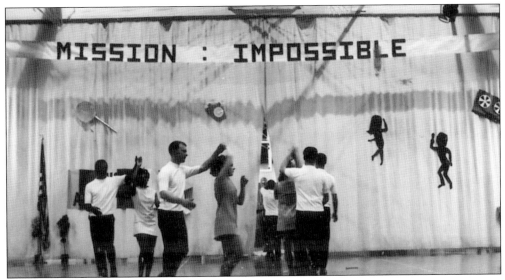

MISSION : IMPOSSIBLE

Each year, Phi Pi Sigma, the physical education society, put on a Christmas program. This was an opportunity for senior physical education majors to exhibit their skills in athletics, dancing, tumbling, and other activities. In this photograph, students are showing their mastery of dance steps.

Actor Esther Rolle portrayed Florida Evans on the popular television show *Good Times*, which depicted a black Chicago family living in housing projects. Rolle visited Chicago State University in 1981. Within her collection at the African American Research Library and Cultural Center at the Broward County Public Library, there is a poem about her from CSU.

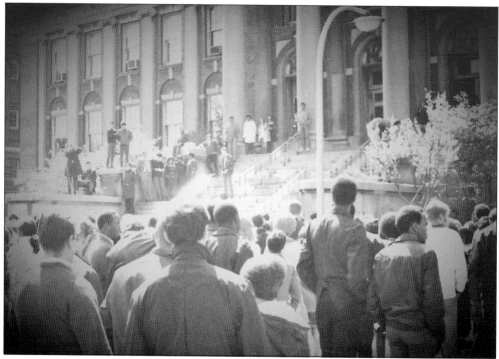

From 1966 to 1969, CSC students held several protests and demonstrations on campus. They protested in support of students having a voice in the retention and firing of faculty and the development of curriculum, specifically the development of a black studies program. Pictured here is one of those rallies.

The Afro-American Organization (AAO) was concerned about bridging the gap between the campus and the community. It started and organized the funding for Project Overdue (1968), which consisted of mentoring and counseling local Chicago public school students in the Englewood neighborhood. Vernita Hunter was a leader in Project Overdue.

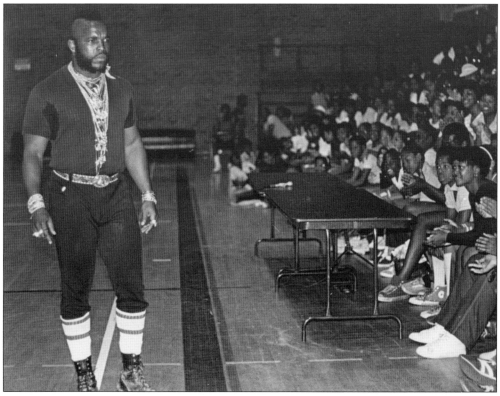

In 1983, actor Mr. T. visited participants in CSU's summer sports program. Every summer, CSU offers programs in a variety of sports, such as volleyball, tennis, soccer, and basketball. These programs are open to any youth who would like to play sports and learn new skills.

CSU offered summer camps for youth in the performing arts. Whether the focus was drama, voice, or instruments, there were opportunities for local schoolchildren to get involved. Pictured is one of those camps.

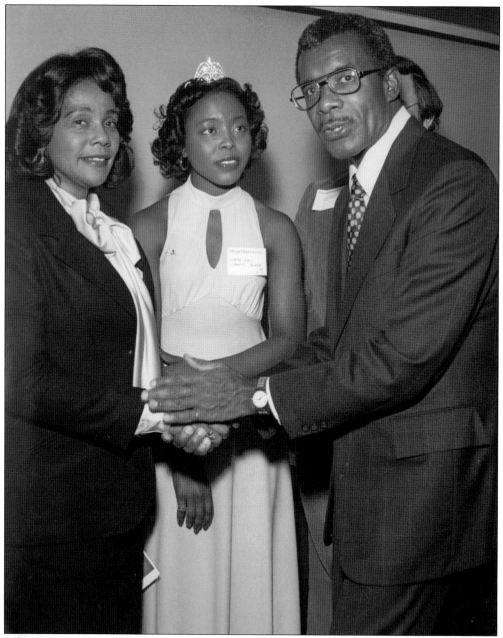

On a visit promoting the Martin Luther King Jr. Center for Social Change in 1976, Coretta Scott King is greeted by Chicago State University's first African American president, Dr. Benjamin H. Alexander, and the CSU Homecoming queen Wanda Ems. The center was established in 1968 in Atlanta, Georgia, to be an institution for local and global change and impact. King spoke about her personal experiences in the civil rights movement as well as the impact of her husband, Dr. King. She concluded her remarks by encouraging those in attendance to make a change in the world.

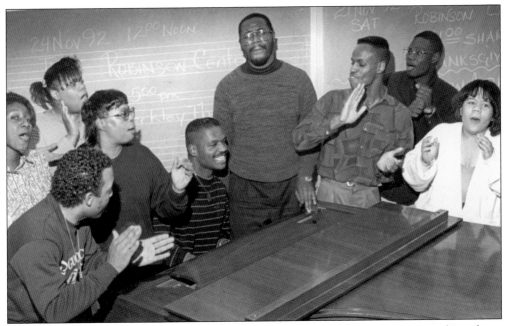

Music has always been an important aspect of Chicago State University. Students have participated in choirs, glee clubs, jazz bands, gospel choir, jazz club, and concert chorus. Some of the students are enrolled in the music department, which provides a variety of bachelor's degrees, while others just have an interest in music. The bands and choirs perform during Black History Month as well as at homecoming and talent shows. Pictured above is a glee club, singing around the piano, while below, the gospel choir performs at a Black History Month celebration.

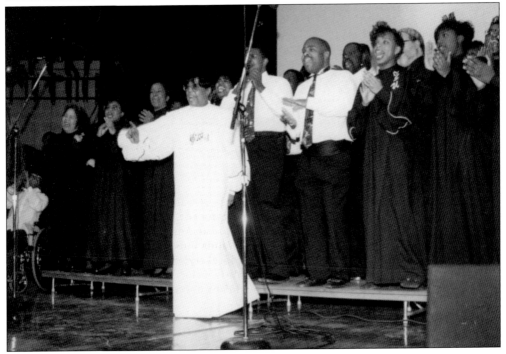

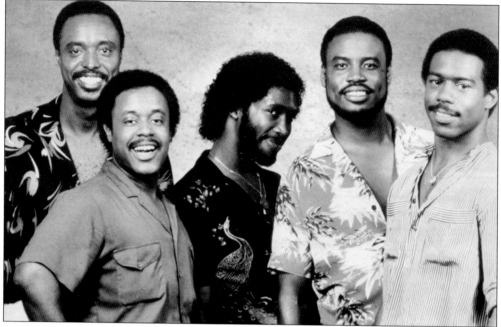

In 1983, the band Brick gave a performance at CSU. Known for their "dazz" (disco-jazz) style, they had many songs on the R&B charts. After 40 years, they are still touring and recording albums.

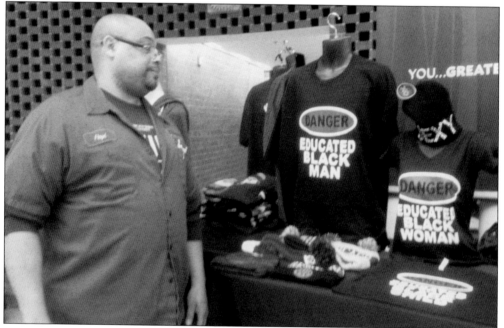

Ujamaa Market provides a space for black-owned businesses to sell their products. At the market, one can find everything from clothing and jewelry to cosmetics and home products. Ujamaa is Swahili for brotherhood and extended family. Each year, CSU hosts the market at the Cordell Reed Student Union–Ronald "Kwesi" Harris Rotunda. Pictured here is Floyd Fussell, a custodian for the university. (Courtesy of Byung-In Seo.)

February is Black History Month. At CSU, it is a time to reflect on the past and celebrate the life of African Americans. There are many events during this month. In this photograph, Phalese Gilmore and Dennis Gunn are performing a modern dance routine.

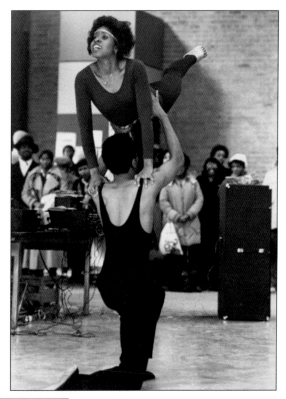

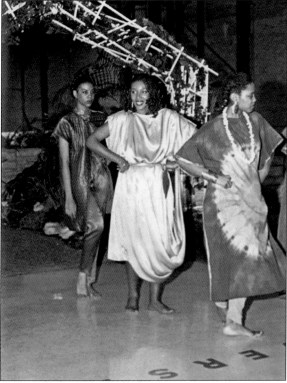

Black History Month celebrations include fashion and step shows, lectures, performances, concerts, and film screenings. These students are part of a fashion show in 1983.

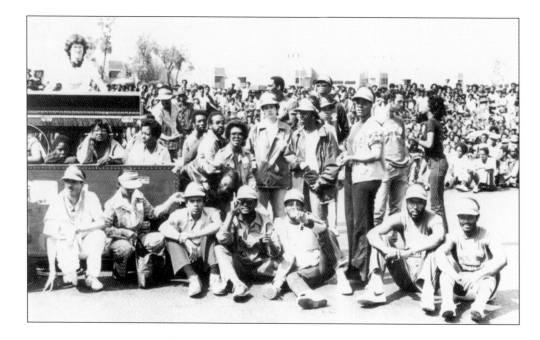

Radio station WVON-AM-FM ("The Voice of a Nation") is based in a western suburb of Chicago; it prides itself on being a source of black talk radio shows that cover issues that affect the black community. The station began in 1926, but did not become a platform to discuss black experiences until 1963. About 1979, WVON, with support from Total Experience Productions, hosted its annual bike-a-thon and concert on campus. Funds raised went to the university.

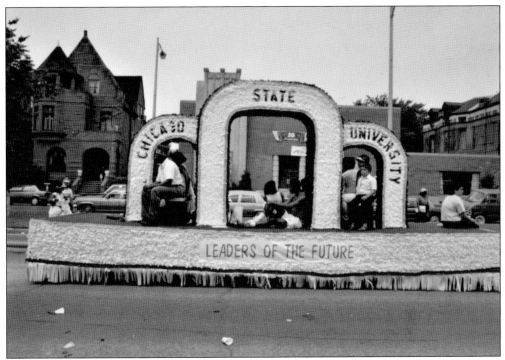

These photographs show Chicago State University students, staff, alumni, and faculty on a float at the Bud Bilken Parade and Picnic. Robert S. Abbott, the founder and publisher of the *Chicago Defender*, started the parade in 1929 in the Chicago Bronzeville neighborhood. Held every year on the second Saturday of August, it is considered to be the largest African American parade in the nation. Focusing on educating Chicago's youth, this parade is considered to be the unofficial kickoff of the new school year.

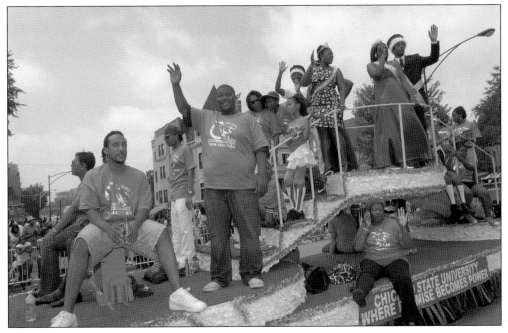

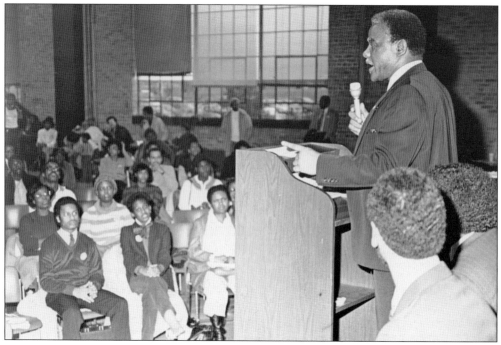

Congressman Harold Washington came to CSU as part of his Chicago mayoral campaign. He was one of the first African American mayors of a major US city. To honor him, CSU dedicated a building to him, Harold Washington Hall, which houses the College of Arts and Sciences.

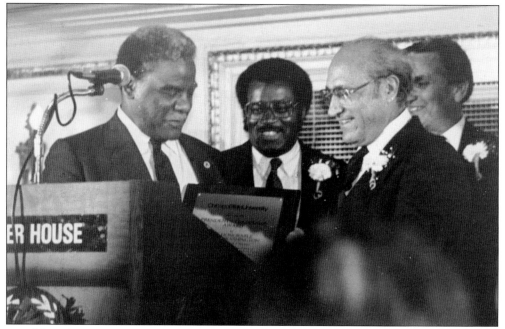

Harold Washington received a President's Leadership Award from CSU president Dr. George Ayers. Washington had supported the university in many ways, including allowing his chief of staff, Bill Ware, to go with Ayers to Liberia to finalize details of a student and faculty foreign exchange program with the University of Liberia.

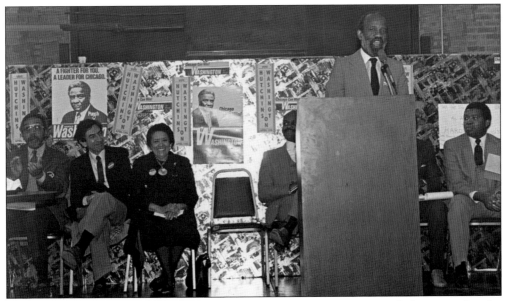

In 1983, Harold Washington became the first African American mayor of Chicago. When he was on the campaign trail, Washington brought along scholar, historian, and *Ebony* editor/writer Lerone Bennett (1928–2018).

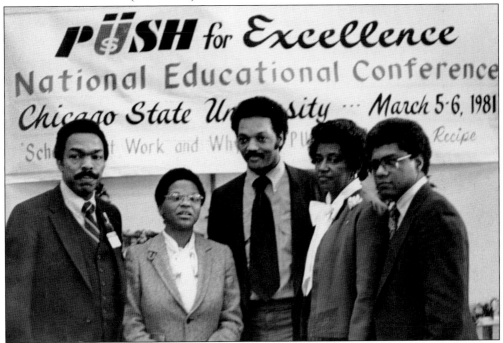

Members of Operation PUSH (People United to Save Humanity) are pictured with founder Jesse L. Jackson Sr. in the center. Operation PUSH was started in 1971 to encourage economic development programs. In 1975, Operation PUSH created a separate organization named Push for Excellence (PUSH Excel), which aimed for school reform on the national and local levels. From 1980 to 1981, the Chicago program expanded from targeting certain schools to focusing on parents and students throughout the city.

This c. 1981 photograph shows Chicago State University students celebrating being back on campus at a back to school dance. Homecoming at CSU is not only a time to attend sporting events, dances, exhibitions, concerts, and food fests, but also an opportunity for students to reflect and appreciate the university and be proud of their accomplishments. During homecoming, alumni also come back to campus. The student government association and others organize the weeklong activities.

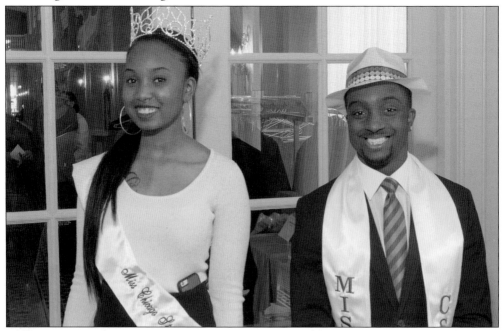

By the 1970s, not only was a homecoming queen elected but also a homecoming king. Titled Miss and Mr. CSU, they become ambassadors for the university at social and academic events. Pictured here are Miss CSU 2017 Miranda Alexandria Terry and Mr. CSU 2017 Jayveon D. Reed. (Courtesy of Jamilah R. Jor'dan.)

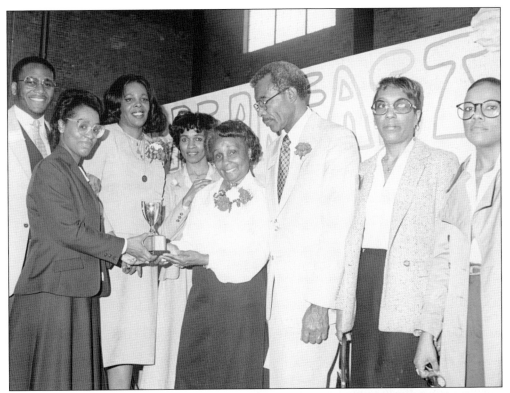

The Mother's Day Prayer Breakfast was sponsored by the CSU Women's Club. At the breakfast, there were speakers and presentations. At the 1981 breakfast, the speakers were Commissioner Lenora Cartwright and reporter Max Robinson. They also gave a Mother of the Year Award, as shown in this photograph. Giving the award is Pres. Benjamin Alexander.

Addie L. Wyatt, an internationally known Chicago-based labor and civil rights leader, was the speaker at the sixth annual Mother's Day Prayer Breakfast. She was the first African American woman to be elected to an office of a major labor union, the Amalgamated Meat Cutters Union.

In 1991, the Calumet Resource Center was established as an effort by the university's Frederick Blum Neighborhood Assistance Center, the Center for Neighborhood Technology, and the Chicago Legal Clinic. The center not only serves the campus, but also the community. It is a place where people can research environmental issues in their local surroundings.

This photograph shows a Christmas celebration at the CSU Child Care Center and Early Learning Program. The program and center were in the Robinson University Center and were dedicated during the 1982–1983 school year. The center hosted the preschool and school-age children of CSU students and employees.

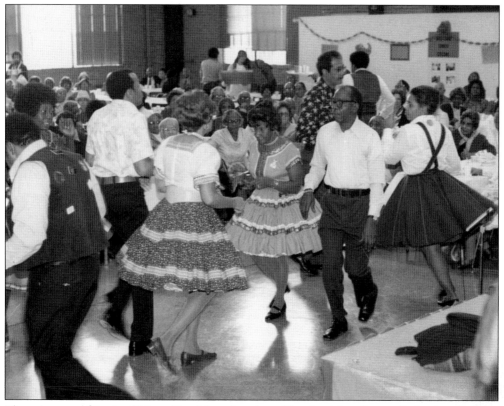

These images of Senior Citizen Day (above) and pre-Thanksgiving dinner (below) at Chicago State University are examples of activities undertaken by the university to engage with the broader Chicago South Side community. These activities brought community members onto campus and demonstrated the university's commitment to community responsibility and enrichment. The pre-Thanksgiving dinner honored senior citizens for their contributions to the community, and was served by CSU students, faculty, and administrators.

The Organization of Latin American Students (OLAS) was created to promote and preserve their heritage on campus. The organization started holding Cinco de Mayo celebrations in 1986, in the Robinson University Center. This image is from the 1990 celebration. Celebrations included mariachi bands, food, and dances. OLAS worked closely with the Office of Hispanic American Affairs, which was established in 1988 and was led by Manuel D. Bustamante.

In 2012, students from the Latino Resource Center participated in the Puerto Rican Parade as part of outreach efforts and support of the Puerto Rican community.

In 2018, CSU students and administrators took a cultural excursion to Cuba. There, they explored the African presence within the country. Their goals were to further understand the social, cultural, and spiritual traditions of the Afro-Cuban community. Pictured here are participants from that trip. From left to right are (first row) Johnathan Riley, Demarcus Wilson, and Justin Washington; (second row) Maurice Dees, Jayveon Reed, Tim Lee, Oscar Lester, Andre Fredricks, Aremu Mbande, and Renard Singleton. (Courtesy of Aremu Mbande.)

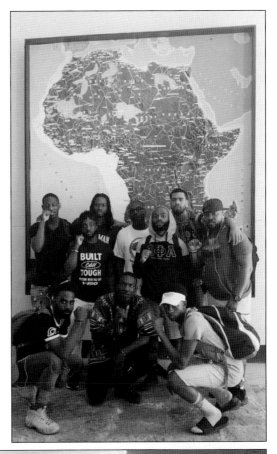

This photograph was taken at the birthday celebration of Baba Ronald "Kwesi" Harris. Baba means father in the Yoruba language of West Africa. The title is given to male elders who exemplify wisdom, love, and guidance. Baba Kwesi's life remains a road map for black men to follow into elderhood. CSU and the African American Male Resource Center continue to use his birth date as an opportunity to shine light on his legacy and lifetime contributions to the black communities of Chicago. (Courtesy of Aremu Mbande.)

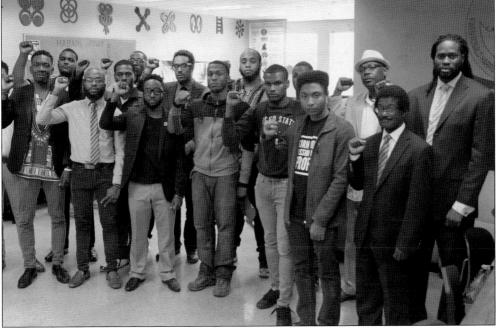

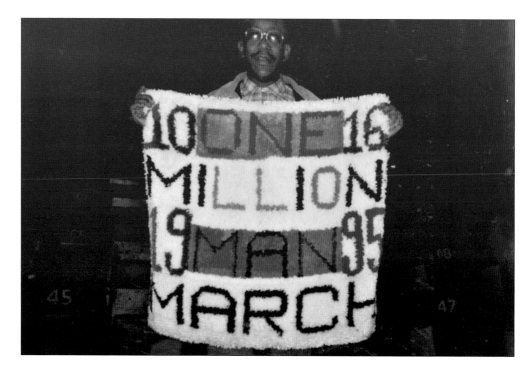

In October 1995, over 500,000 people, mainly African American men from across the nation, converged on the National Mall in Washington, DC, for the Million Man March. The march was organized by Nation of Islam leader Louis Farrakhan to shine a light on issues facing African American men and, ultimately, the future of African American communities. Participants came from all ages, religions, and institutions. Busloads of CSU students traveled to Washington. In 2015, for the 20th anniversary of this historic moment, CSU students again took the journey to partake in the event, pictured below. (Below, courtesy of MaToya Marsh.)

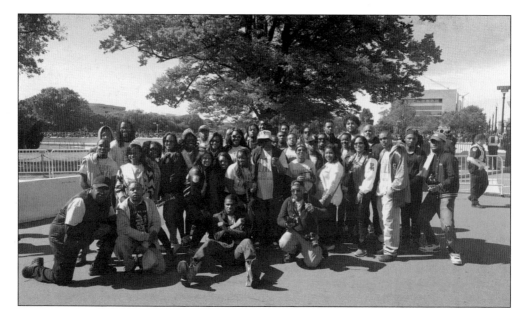

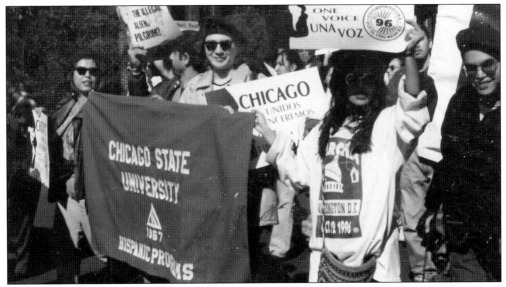

On October 12, 1996, all Latinos and Latinas were called to join a historic civil rights march in Washington, DC. The purpose of this march was to denounce the constant political and economic attacks against their communities. A strong delegation of students from CSU's Hispanic programs joined hundreds of others.

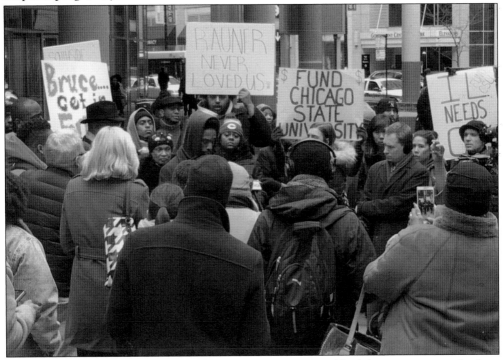

For two years (fiscal years 2015 and 2016), the Illinois Assembly did not pass a state budget, which left many state agencies, including the colleges and universities, without any state funding. The lack of funding resulted in furloughs, layoffs, and threat of closure for CSU. However, students rallied and protested the threat of closure. Here, they are pictured in front of the State of Illinois Building in downtown Chicago. (Courtesy of Richard Darga.)

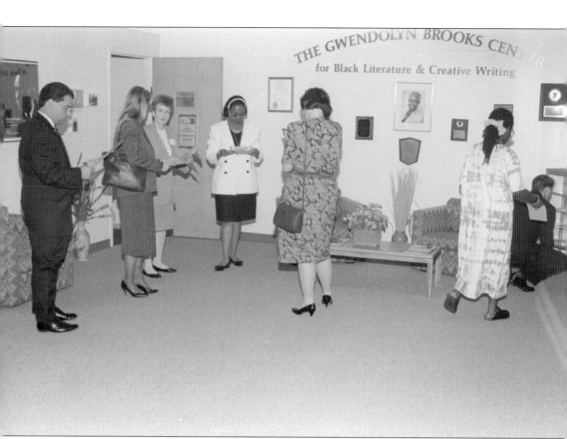

Pictured is the interior of the Gwendolyn Brooks Center (GBC) for Black Literature and Creative Writing in Douglas Library (now Hall). When the center opened in 1990, it was one of the first in the country to support the study of black writers and their contributions to the humanities. The center was inspired by Gwendolyn Brooks, who was a professor of English at CSU until her death in 2000; she was also poet laureate of the state of Illinois and a Pulitzer Prize–winning author (1950). In 1991, the Gwendolyn Brooks Conference for Black Literature and Creative Writing was started. The conference invited black writers to participate in panels, lectures, film screenings, and workshops on campus. At the eighth Gwendolyn Brooks Conference in 1998, the Literary Hall of Fame for Writers of African Descent was launched. The hall of fame honors creatives—living and deceased—and places a special focus on Illinois artists. In order to publish black creative writers, GBC began the biannual literary journal *WarpLand: A Journal of Black Literature and Ideas*, in 1994.

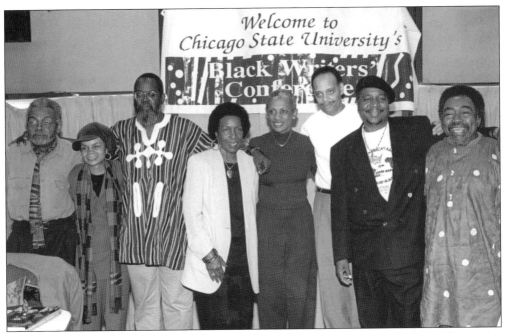

This image from the Gwendolyn Brooks Black Writers Conference shows, from left to right, Amiri Baraka, Sonia Sanchez, Kalamu ya Salaam, Mari Evans, Pres. Delores Cross, Haki Madhubuti, Eugene B. Redmond, and Askia Toure. The conference allowed writers and attendees to meet with other black writers, discuss issues relating to black life, learn about new work, and workshop their material.

Brooks (center) is pictured with poet and author Sonia Sanchez (right) at the first Conference for Black Literature and Creative Writing. Sanchez came back to campus several times to participate in the conference. She is known for her writings during the Black Arts Movement. She is the recipient of both the Robert Frost Medal for distinguished lifetime service to American poetry and the Langston Hughes Poetry Award. In 1999, she was inducted into the GBC Literary Hall of Fame.

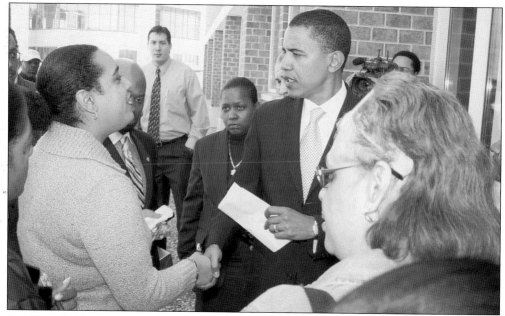

Sen. Barack Obama was the keynote speaker of the seventh annual Turning of the Centuries Conference at Chicago State University on April 8, 2005. As a young community leader and activist, Obama spent time in the neighborhoods surrounding CSU. He was inducted as an honorary member of the Honors College. In this photograph, he is speaking with students at the conference.

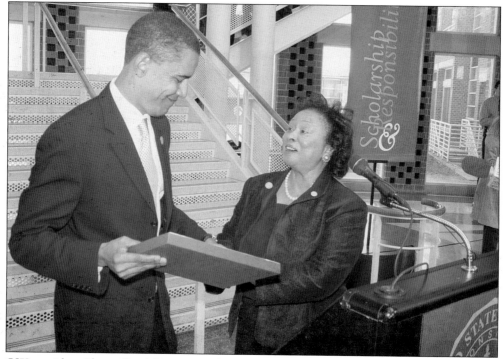

CSU president Elnora Daniel is giving Obama a gift of appreciation for his talk at the seventh annual Turning of the Centuries Conference in 2005.

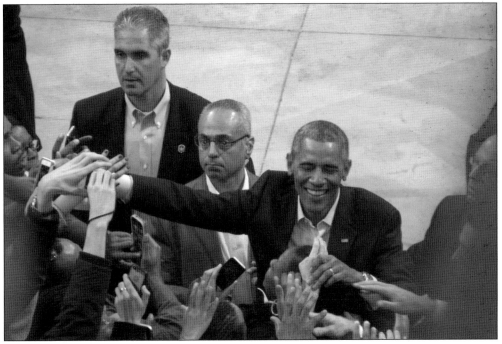

In 2014, Obama returned to CSU as the president of the United States to support incumbent Illinois governor Pat Quinn. Here, he is working the crowd—his signature style. (Courtesy of Byung-In Seo.)

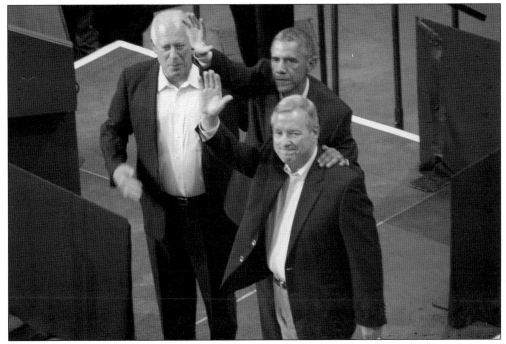

President Obama shares the stage with Governor Quinn and US senator Dick Durbin. Both Quinn and Durbin ran for reelection. Senator Durbin kept his seat, while Gov. Quinn did not. (Courtesy of Byung-In Seo.)

In 1990, CSU hosted the Educate Your Body 5K run and walk. It was started by Pres. Dolores Cross, who believed that health and fitness needed to be a lifestyle. The goal of this event was to test the participants' endurance, build bridges between CSU and the community, and raise scholarship money. In 2009, this event was revived as the Arthur Stephens Scholarship Walk. Stephens was a beloved CSU professor who participated in the original Educate Your Body event. After his retirement in 1991, he continued to stay active at CSU. Known as "Campus Dad," Stephens enjoyed helping the student editor of the *Tempo* and counseling evening students.

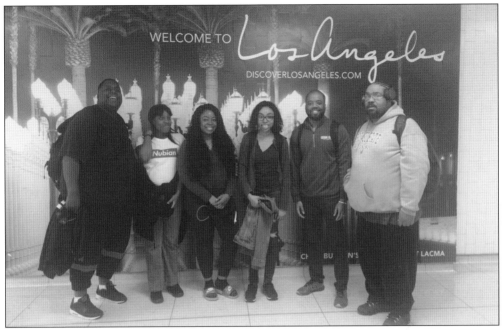

In 2017, CSU competed in the final round of the Honda Campus All-Star Challenge in Los Angeles, California. This team was one of 48 that made it to the finals. The team consisted of, from left to right, students Isaiah Samuels, Kayla Mensa, Courtney Jenkins, and Nicollette Sanders, and moderators Olanipekun Laosebikan and Brandon Morgan. (Courtesy of Olanipekun Laosebikan.)

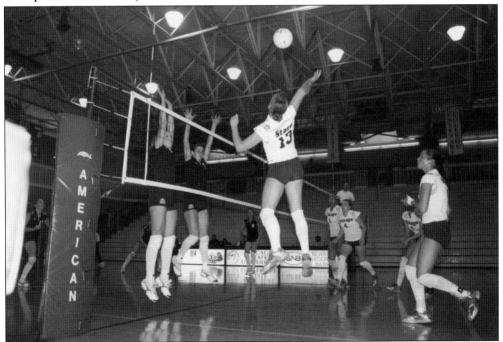

Here, a member of the Chicago State University women's volleyball team spikes the ball against her opponents.

At a College of Education alumni reunion in 2011, Mark Simmons spoke about being a CSU alumni and then doctoral student, who was concurrently working as an assistant principal in Chicago Public School District No. 299. Simmons earned his bachelor of science in elementary education in 2000, a master of arts in educational leadership in 2006, and a doctorate of education in 2011. (Courtesy of Mark Simmons.)

Each year, the College of Education has a Mardi Gras celebration in May, which honors professors' and students' accomplishments. In 2017, the celebration included the sesquicentennial kickoff event for CSU's 150th anniversary. Proceeds from the event directly benefit College of Education students through both merit and need-based scholarships. From left to right are Marlon Conway, Kimberly Black, Chrystal Sanks, Angela Henderson, Rachel Linsdey, Jamilah R. Jor'dan, and Francis Morkeh. (Courtesy of Jamilah R. Jor'dan.)

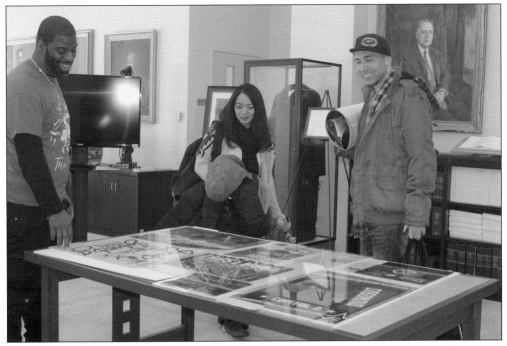

On February 28, 2015, CSU hosted the symposium Preserving the Beats: Collecting Chicago Hip-Hop. This symposium was hosted by the Chicago State University Archives and Special Collections and the Gwendolyn Brooks Center for Black Literature and Creative Writing, and discussed and examined how to collect and preserve hip-hop as a culture and a musical form, and explored the importance of hip-hop to Chicago history and the collective black experience globally. In this photograph, members of the Chicago hip-hop scene Che "Rhymefest" Smith (left) and Konee Rok (right) are viewing the exhibit. (Courtesy of Aaisha N. Haykal.)

Panelists of the State of Black Studies in Higher Education pictured here are (from left to right) Faheem Abdur-Rasheed (CSU alumnus), Alexis Mayfield (CSU alumna), Dr. Zoe Franklin (City Colleges of Chicago), Prof. Armstead Allen (City Colleges of Chicago), and Dr. Kim Dulaney (CSU professor). The session took place in 2014 to understand how black studies was created as a field, the importance and impact of black studies, and how the field is under attack. (Courtesy of Aaisha N. Haykal.)

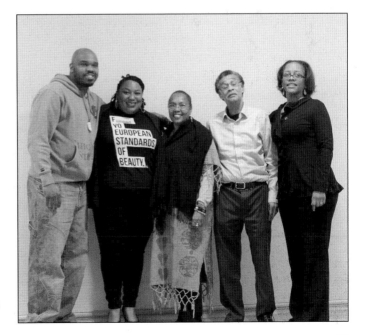

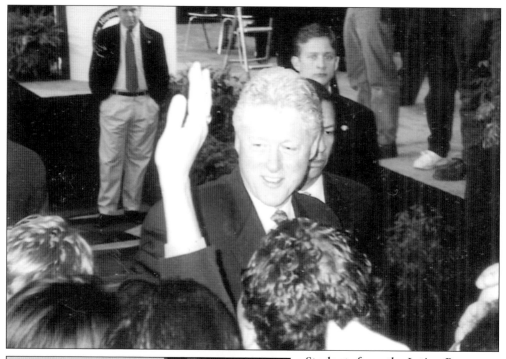

Students from the Latino Resource Center met Pres. Bill Clinton at a national Hispanic conference in Chicago. In 1992, President Clinton received 61 percent of the Latino vote, and in 1998, he received 72 percent of the Latino vote.

Thomas N. Todd is a Chicago-based lawyer and activist. A consistent advocate for civil rights, Todd fought both publicly and behind the scenes for the election of black leaders, including Rep. Ralph Metcalfe and Harold Washington's Chicago mayoral races in 1983 and 1987. He also helped to establish the historic Afro-American Patrolmen's League in 1968. His papers were deposited at Chicago State University in 2013; he is pictured here at the closing reception of his paper's exhibit in 2014.

Pictured are, from left to right, Judge R. Eugene Pincham's daughter Andrea Michelle Pincham-Benton; attorney Lewis Myers, former CSU instructor of criminal justice; and Robert Benton. They met to discuss the legacy and importance of Judge Pincham and how to engage the student body in his history and the issues he fought for. While there, they also viewed a pop-up exhibit featuring Pincham's papers. (Courtesy of Aaisha N. Haykal.)

Pat Bearden is a Chicago Teachers College alumna and co-founder of the International Society of Sons and Daughters of Slave Ancestry (ISDSA). Founded in 1999, ISDSA has collected images and oral histories of former slaves who lived to experience freedom. All photographs and oral histories were submitted by living descendants. In 2015, ISDSA began to partner with CSU to digitize the 400 photographs, which were taken around the turn of the 20th century. (Courtesy of Aaisha N. Haykal.)

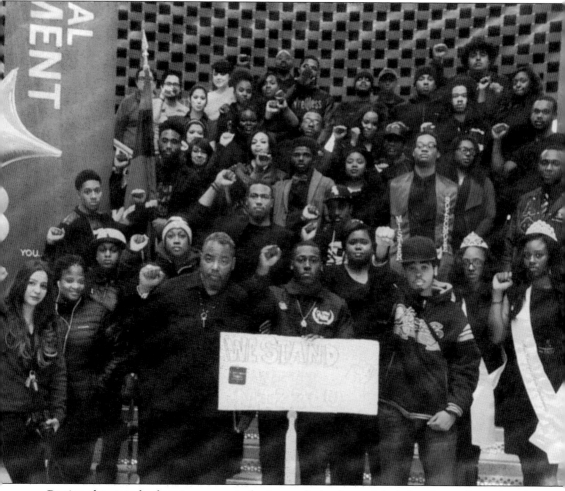

During the state budget impasse, students regularly showed their loyalty to the university. This photograph shows the student government association's unity and support for the university. Students and faculty used social media, as well as traditional forms of media, to garner support for the university and to demonstrate the importance of the campus. The student government association has consistently been the voice of students, advocating for student needs and concerns to both the school administration and external parties.

Three

THOSE WHO TEACH

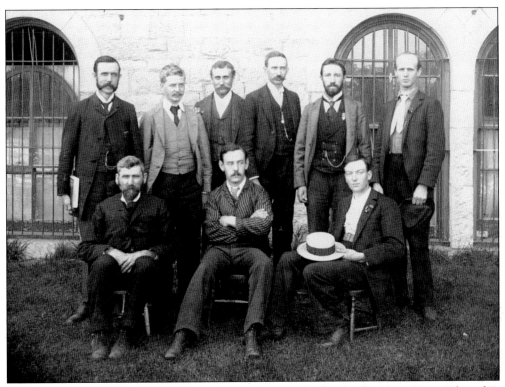

In 1911, there were 15 male teachers at Chicago Normal School: John T. McCanis, Edward E. Hill, James Hosic, Cyrus L. Hooper, Harry S. DeVelde, Frederick W. Buchholz, Edgar E Hinkle, George W. Eggers, Oscar L. McMurry, Elmer A. Morrow, Henry W. Fairbank, Joseph W. Dows, John W. Shephard, Grant Smith, and Aaron H. Cole. Of this group, nine are pictured here.

Teacher education started in the 1830s in New England. Teacher training schools were secondary schools with special departments. It was one to two years of training in the science and art of teaching. In 1860, Cook County commissioners felt that teachers from Chicago were better trained and knowledgeable in their craft. In 1867, the Cook County Board of Supervisors agreed to open Cook County Normal School in Blue Island, Illinois. Daniel S. Wentworth was its first principal. Under Wentworth's leadership, the school grew in enrollment and influence and quickly achieved a national reputation.

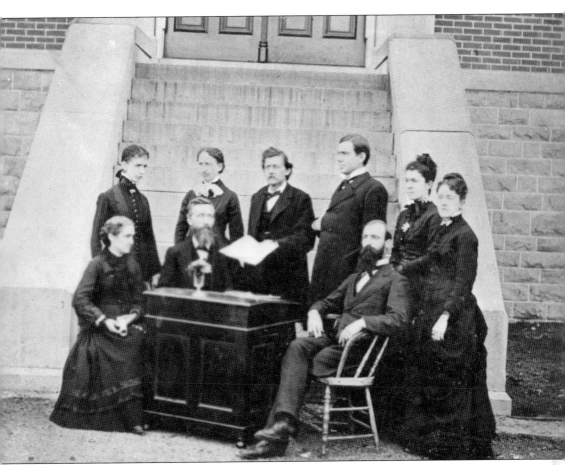

Cook County Normal School principal Daniel Wentworth (center) is pictured in front of the school with members of the faculty. From left to right are (seated) Sarah Byrne, Prof. W.C. Shuman, and William Dodge; (standing) Sarah M. Curtis, Eleanor Worthington, Wentworth, John Byrne, Helen Montfort, and Emily Rice. The Cook County Normal School was the first of its kind in the United States west of the Appalachian Mountains. Until this time, normal schools were all in the northeastern United States. The school year lasted for 40 weeks and was divided into three terms: fall, winter, and spring. In 1879–1980, the school taught 232 students in the normal department and 173 in the training and preparatory departments, for a total of 405 students.

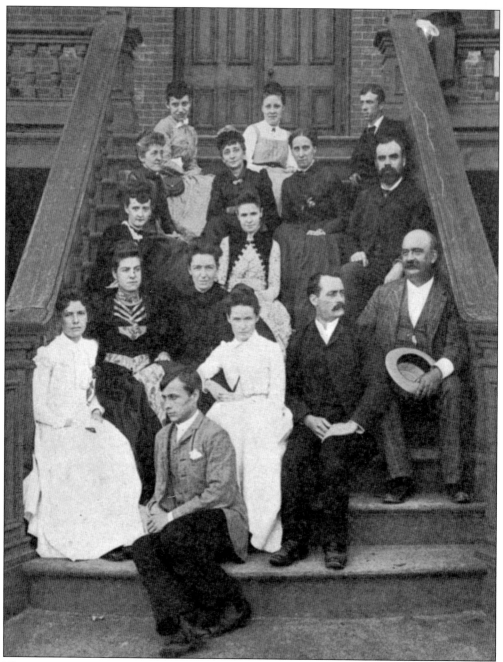

This 1889 photograph shows principal Francis Wayland Parker and the faculty of Cook County Normal School. Parker became principal when Daniel Wentworth died in 1888. He believed that the purpose of education in a democratic society was to develop students with democratic attitudes and a commitment to democratic values essential for effective citizenship. Regular students lived on campus and enrolled in a one-year course, which included observations and fieldwork at an onsite model elementary school.

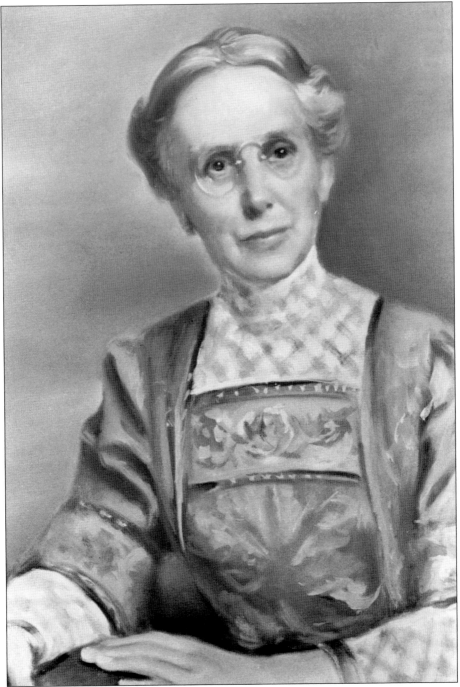

Ella Flagg Young was the first female principal of Chicago Normal School. At 16 years old, she attended the teacher training program and earned a teacher's certificate; 45 years later, she became principal of the school. She envisioned the school to be a three-year program, where certified teachers could return to school and earn a bachelor's degree. Due to bureaucracy and perceived expense, this idea was not pursued. However, it did lay the groundwork for the school to eventually become a college.

The following Chicago Normal College Faculty Members were transferred to other schools on February 1st, 1932, with the exception of Miss O'Sullivan who was transferred on March 28, 1932:

Instructor	Yearly Salary
Ruth Beckley ?E	$3400
Dorothy Bresnahan ?E	3800
Beale E. French -Sc	4000
Robert G. French Graphic Arts	4000
Helena Gavin Eng	4000
Clarence W. Gifford Eo.	3000
William L. Kaiser Hist.	3000
Josephine Lee Music	3200
Teresa O'Sullivan Ushd arts	4000
Claude P. Shideler Sci	4000
Catherine M. Taheny Awll	3600
Ira N. VanHise Geog	4000
Margaret M. Skinner (Substituting in vacancy)	1800

Total Annual Salary Saving in The Chicago Normal College Budget $45800

This page lists the names and salaries of teachers who transferred to other schools. The Great Depression of the 1930s had an effect on the Chicago Normal College operations. Enrollment decreased; faculty size had to be reduced, as seen from this memo; and remaining faculty had payless pay periods. In order to save expenses, the board of education planned to close the school. However, with tremendous support from the students and faculty, it remained open. By the 1940s, enrollment started to increase. To save money, many students chose to commute from home to college.

In 1966, Dr. Milton Byrd became president of Chicago Teachers College. Despite the school's aging facilities, enrollment was increasing when Byrd took over. Between student and faculty activism and governances, and the need to improve learning opportunities for the students, one of Dr. Byrd's responsibilities was to transition the college to a university. In this photograph, Byrd is speaking to students and guests at the hockey team's end-of-season banquet.

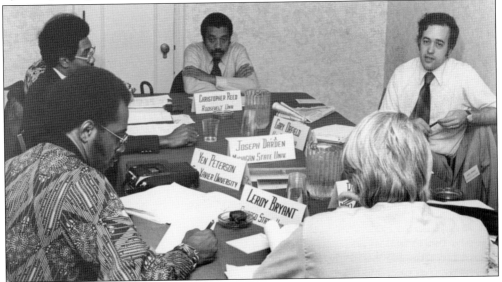

The Racial Harmony symposium featured university professors from around the nation discussing Americans' race problems from their disciplines of history, political science, geography, therapy, and social work. Pictured here, professors from Roosevelt University, St. Xavier College, and Michigan State University joined CSU professors.

In 1966, student and faculty governances were becoming more important. The college senate was a governing body of faculty that worked to enact policies with direct impact on the college. The college senate and the student government association worked together, so that all voices would be considered. The college senate eventually became the present-day faculty senate.

This photograph was taken during Professor Emerita Dorothy Kozeluh's retirement party in 1991 at the Beverly Country Club. From left to right are Sid Miller (professor emeritus), Lorraine Pink Benkovich, Dorothy Kozeluh, Bob Szyman, and Mary Sybil Dunne. (Courtesy of Robert and Marie Szyman.)

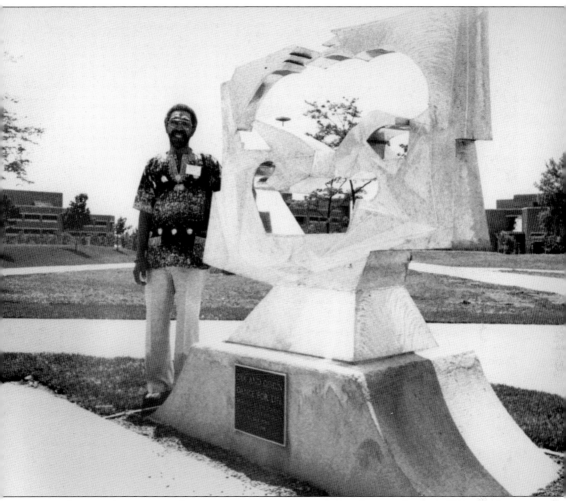

Dr. Ausbra Ford, a native Chicagoan, was an associate professor of art at Chicago State University. His research interests included African funeral art and religious traditions, and he has exhibited in Chicago and in the Midwest. In June 1981, this sculpture, titled "Oya and Oshun Dance for Life," was dedicated to the students of Chicago State University. Ford has also sculpted work for the DuSable Museum of African American History and another piece on campus, titled "Struggle for Freedom."

The College of Health Sciences, which was originally named the College of Nursing, achieved National League for Nursing accreditation in 1981. Pictured are two deans of the college, Dr. Berlean Burris (left), who served from 1984 to 1991 and from April to August 2009, and Dr. Linda Simunek, who served from 1980 to 1983. Simunek was the second dean of the college.

Herb Kent was a professor in CSU's communications department. He is pictured speaking to a class. Kent was also a disc jockey on WVON and on campus radio station WCSU in 1996. Known for wearing his signature cowboy hat, he was nicknamed "the Cool Gent."

Marva Jolly (1937–2012), artist, sculptor, and CSU professor of ceramic, is with CSU president Delores Cross in 1993 at the opening of her exhibit "Old People Say." The exhibit, which was inspired by her childhood, consisted of 54 panels/pots on an L-shaped wall that celebrated the wisdom of ancestors. Jolly had a studio on campus called the Mud Peoples Studio.

Gwendolyn Brooks (left) co-taught with close friend Haki Madhubuti (right). They are pictured here at the 125th anniversary kickoff celebration for the university. Brooks read a poem dedicated to the faculty, staff, students, and alumni of CSU. Within the poem, she stated the importance of the university and the impact the institution has had on the nation. She also noted that if the institution and its students believe in themselves, they can and will get things done. This message resonates with the mission and history of the university.

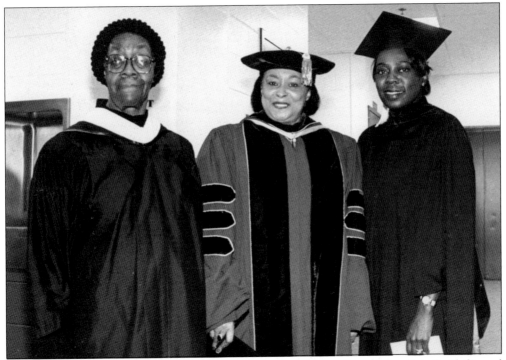

This photograph, taken at the 1999 commencement, shows Gwendolyn Brooks (left) and Pres. Elnora Daniel (center).

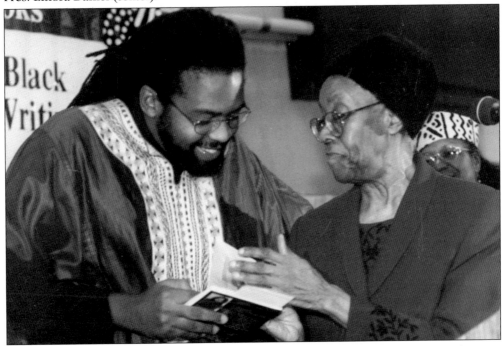

Quraysh Ali Lansana, poet and former CSU professor and Gwendolyn Brooks Center director, is pictured with his mentor, Gwendolyn Brooks, at the Gwendolyn Brooks Conference on Black Literature and Creative Writing.

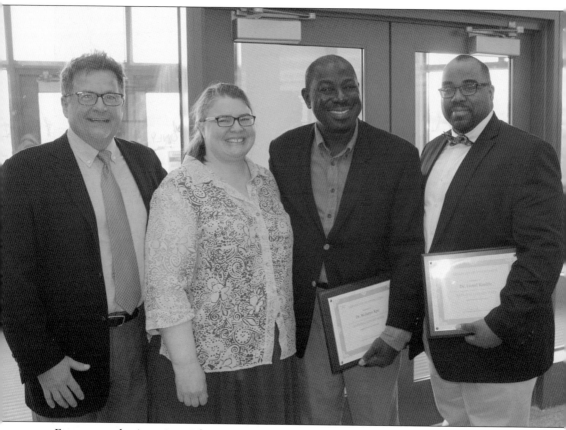

Every year, the American Library Association has a National Library Week. During this week, the library has different activities, including workshops, book sales and giveaways, lectures, and tours. Additionally, the librarians recognize faculty who have been supportive of the library. Pictured here in 2015 are Dr. Richard Darga, dean of library and instruction services; Gabrielle Toth, library chair; and honorees Dr. Wolanyo Kpo, professor of management and information systems; and Dr. Lionel Kimble, professor of history.

Dr. Julian Scheinbuks was a tenured professor of biology. He worked as an educator and researcher at CSU for more than 20 years. For his first 10 years, he was a teacher, mentor, and researcher in the biology department. In 2002, he came out of retirement to start the distance learning and online education program at CSU. He was appointed director of the Office of Distance Learning, growing the program tenfold during his tenure. He passed away in 2010, and in 2011 everything he earned was bequeathed to the CSU Foundation. The $1 million endowment is the largest donation to the university by a faculty member. This money provides scholarships for students in biology and for development of the online and distance learning programs. (Courtesy of Byung-In Seo.)

All doctoral candidates write a dissertation, which is evaluated by a committee. The committee is comprised of faculty from all over campus. Pictured are, from left to right, Dr. Paula Carney, Dr. Byung-In Seo, doctoral student Kina Brown, and Dr. E. Justy Reed. (Courtesy of Byung-In Seo.)

At CSU, faculty, staff, and administrators are encouraged to be lifelong learners. Many staff and middle-level administrators take advantage of the opportunity to pursue additional certifications and degrees. DeWitt Scott, at center, was the director of the Office of Field Placement in the College of Education. In 2016, he earned his doctorate of education in educational leadership. From left to right are Dr. Dawn Hinton, Dr. Lionel Kimble, DeWitt Scott, Dr. Byung-In Seo, and Dr. Olanipekun Laosebikan. (Courtesy of Byung-In Seo.)

In teacher education, students are taught to respect the support staff, especially the custodians and administrative assistants. They learn that the support staff can either help or hinder their work. In the photograph above are custodian Andre Russell and administrative assistant Desiree Montgomery. At right is Chrystal Sanks, the advisor specialist in the doctoral studies department. These three people work in concert to make sure that the programs run smoothly. (Both courtesy of Byung-In Seo.)

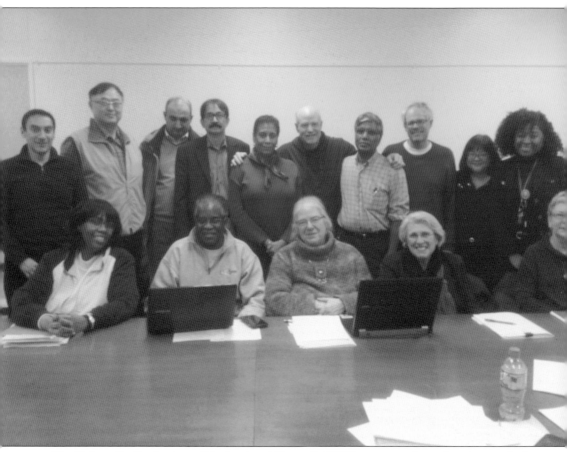

The University Graduate and Professional Council (UGC) serves as the university curriculum committee for all graduate and professional curriculum and policy matters. UGC is comprised of voting members (one faculty member per graduate or professional program) and nonvoting members. Pictured are, from left to right, (seated) Brenda Aghahowa, Athenase Gahungu, Barbara Leys, Patricia Steinhaus, and Margaret Kelly; (standing) Gabriel Gomez, Jan Jo Chen, Moussa Ayyash, Muhammed Sallahuden, Sheri Syfried, Dan Hrozencik, Devi Potluri, Danny Block, Byung-In Seo, and Bobbie Harth. (Courtesy of Byung-In Seo.)

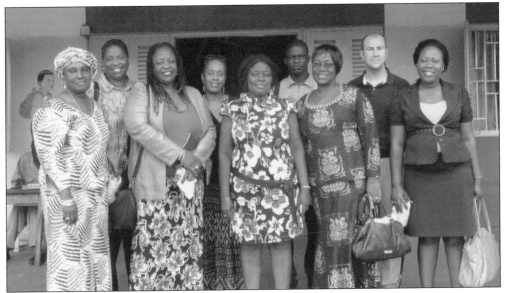

The Merger Project sponsored by the US Agency for International Development (USAID) is a collaboration of two USAID-sponsored projects, Textbooks and Learning Materials Program and the National Acceleration of Literacy Program, both designed to improve and accelerate literacy among Ghana's basic education pupils. CSU faculty served as program technical advisors of the Merger Project. In this photograph, among the teachers of Adenta Community Kindergarten are faculty members Jamilah R. Jor'dan, Miguel Fernandez, Evelyn Delgado-Norris, and coordinator Jamille Barnes. (Courtesy of Jamilah R. Jor'dan.)

In the summer of 2011, faculty and administrators in the College of Education and the College of Arts and Sciences traveled to Addis Ababa, Ethiopia, to meet faculty and administrators. The goal was to develop partnerships between the two universities. CSU faculty members are Dr. Mikal Rasheed, professor of social work (third from left); Dr. Aida Abraha, associate dean of College of Arts and Sciences; and Dr. Athanase Gahungu, professor of educational leadership. (Courtesy of Athanase Gahungu.)

In 2017, the College of Education's Mardi Gras celebration included the sesquicentennial kickoff event for CSU's 150th anniversary. Proceeds from the event directly benefit College of Education students. One of the award recipients was Dr. Debra Nelson, associate professor in the Department of Secondary Education, Physical Education, and Recreation. She was awarded the CSU Alumni Service Award. (Courtesy of Jamilah R. Jor'dan.)

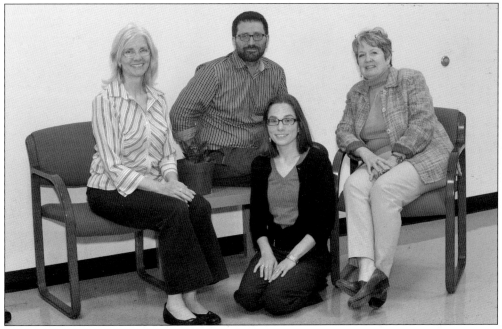

From left to right are Karel Jacobs, Mel Sabella, Andrea G. Van Duzor, and Rita Koziarski, members of the CSU Science Education Team. They work with CSU biology, chemistry, and physics majors who are pursuing secondary education degrees. During this time, for the first time, CSU had two major grants to support students entering the science teaching: the National Science Foundation Noyce Grant (CSU's first) and American Physical Society PhysTEC Grant (also CSU's first).

Interim president Dr. Rachael Lindsey (right) is pictured with Lillian Kay Dawson, chair of the Art and Design department. (Courtesy of Jamilah R. Jor'dan.)

Faculty at CSU are expected to present and publish in academic venues. In this photograph, associate professor Dr. Crystal T. Laura (right) is speaking with a fellow researcher at the American Education Research Association Conference. They were discussing aspects of her book *Being Bad: My Baby Brother and the School-to-Prison Pipeline.* (Courtesy of Byung-In Seo.)

In 2005, Dr. Gabriel Gomez went to Aligarh Muslim University as a Fulbright lecturer through the Library and Information Science Award. In 2017, he was invited to the International Conference on Knowledge Generation, Discovery and Networking (KGDAN-2017) by the Department of Library and Information Science at Aligarh Muslim University in Aligarh, India. Here, Dr. Gomez is receiving flowers from Dr. Nishat Fatima, an associate professor in the Department of Library and Information Science at Aligarh Muslim University. (Courtesy of Gabriel Gomez.)

Pictured here is Garrard McClendon with his book *Donda's Rules*. Dr. Donda West was chair of the English department for many years. During her tenure at CSU, she published academic articles on general systems theory and rhetoric and the use of ebonics in Chicago Public Schools along with poetry and other creative works. While other scholars concentrated only on publishing and teaching, Dr. West focused on nurturing students at Chicago State while raising her son, artist Kanye West. McClendon collected the best of her writings to publish this book. (Courtesy of Byung-In Seo.)

Pictured from left to right are provost Dr. Angela Henderson, interim president Dr. Rachael Lindsey, interim dean Dr. Jamilah R. Jor'dan, and interim associate provost of academic affairs Dr. Satasha Green. (Courtesy of Jamilah R. Jor'dan.)

Pictured here are Dr. Flora Luseno, chair of the Graduate and Professional Studies department, and Dr. Mark Kutame, associate professor of physical education. (Courtesy of Jamilah R. Jor'dan.)

Drs. Robert Szyman and Debra Nelson, both professors of physical education, enjoy a moment at the College of Education's Mardi Gras in May. Both are alumni who returned to teach at CSU. (Courtesy of Jamilah R. Jor'dan.)

Dr. Mel Sabella engages CSU students in the following critical thinking question: if a bear walks 30 miles south, 30 miles east, and 30 miles north and ends up back where it started, what color is the bear? (The globe is a hint and only comes out after students have thought about the question.) (Courtesy of Mel Sabella.)

In 2005, Clarence Fitch received the Living Legend Award from the National Council for Professors of Educational Administration (now International Council for Professors of Educational Leadership). Fitch was a pioneer in educating teachers to become administrators. His work provided a basis for CSU's General Administration Licensure program. Celebrating are, from left to right, Athanase Gahungu, Leon Hendricks, Clarence Fitch, Chandrasena Cabraal, Olive Gahungu, and Shirley Fitch. (Courtesy of Athanase Gahungu.)

In 2010, the doctorate of education program became the Department of Doctoral Studies. In this photograph are the founding members of the department (from left to right), Chandrasena Cabraal, Carol Schultz, Byung-In Seo, and Leon Hendricks. (Courtesy of Byung-In Seo.)

Four

WHERE LEARNING OCCURS

In 1981, Illinois Central Gulf Railroad donated a boxcar to CSU. This boxcar represents the humble beginnings of the university. In 1867, Normal Teacher Training School started in a leaky boxcar on the rail yards in Blue Island, Illinois. Made into a museum, this boxcar now sits on CSU's campus near Harold Washington Hall. (Courtesy of Nancy Grim Hunter.)

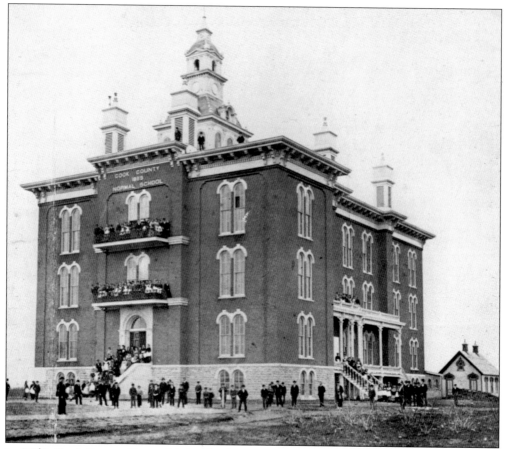

In 1869, Cook County Normal School relocated to a new village called Englewood, which was south of Chicago's city limits. Then, in 1897, the Chicago Board of Education took over the school, changing the name to Chicago Normal School. This site became the permanent location of the school for over 100 years. The 1870 photograph above shows the school in Englewood. By 1905, an updated building was erected, pictured below.

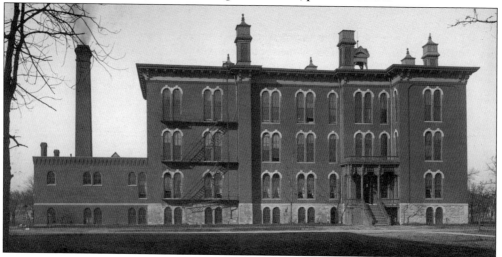

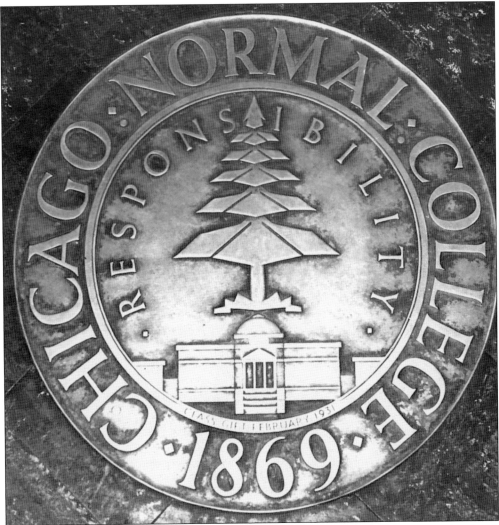

Though the official seal of Chicago Teachers College has 1869 as the year the school was founded, it was a teacher training school as early as 1867; however, it was in 1869 that the school was legally authorized to begin teacher education in Englewood. Also on the seal are the Dome Building and a tree, which represent knowledge, strength, and stability. The word "responsibility" guides the university in its mission.

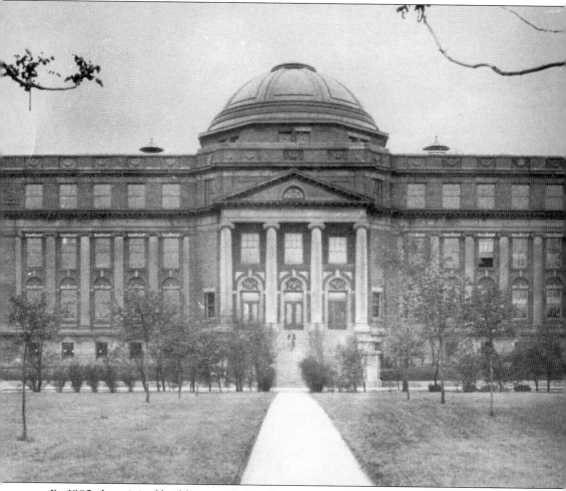

By 1905, the original building needed updates. During the renovation, additional classrooms were built, structural damages were fixed, and a gold dome was added. The cornerstone was laid in 1910. This photograph from 1912 shows the dome. There was protest over the gold dome because it did not properly reflect the Chicago architecture style. Eventually, the primary use of this part of the building was for homemaking arts.

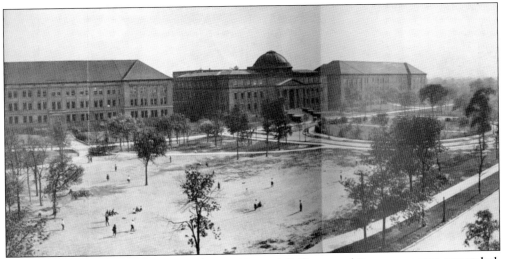

In 1913, the school was renamed Chicago Normal College, and its campus was expanded. This photograph shows the campus in 1918. The school was on the corner of Sixty-third Street and Stewart Avenue. Pictured are the Dome Building, two practice schools, and a dormitory. The two schools are Haines Practice School, an elementary school; and Parker Practice School, one of the three junior high schools in Chicago. Parker Practice School had a deaf-oral program. Considered a premier program for hearing-impaired children, students throughout Chicago enrolled here. The dormitory housed students who lived outside the city limits of Chicago.

The Deaf Oral Department

The Deaf Oral Department in the Chicago Teachers College was organized in the year 1906 with Miss Mary McCowen as head of the department. It is a one-year graduate course and scholarships of $300 each are offered by friends of the department.

The classes for the deaf in the Parker Practice School furnish opportunity for practice work to students taking this course. There are at present nine such classes, and in them one may see all the steps in the process from the little children just beginning to learn the names of things to the larger children who are doing acceptable grammar grade work, using speech as the means of communication. Students who have visited these classes for the first time through curiosity will surely, if interested in psychological problems, wish to go again to observe the processes in the gradual development of mind, which are here made so clear.

The deaf oral program began in 1906. Students in this program learned how to teach speaking skills to deaf children. By 1918, there were three clinics throughout Chicago. In the 1930s, students learned how to teach those who were physically handicapped and, by the 1950s, learned how to teach those who were cognitively impaired. By 1969, all of these programs merged to become the special education department.

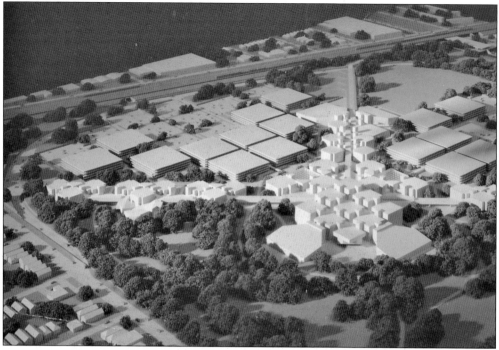

The image above is a model by Perkins and Will, the architects for the new campus. They believed that there would be a central core to the campus. The photograph below is of the new campus under construction. Ground was broken in September 1970, with an estimated 26-month building plan, for Phase 1. Throughout the two-year period, there were weather- and budget-related delays. In October 1972, it was decided that the campus would open the next month. From October 28 to November 20, classes were suspended while the campus moved from Englewood to Roseland. Ultimately, construction was not completed until 1974.

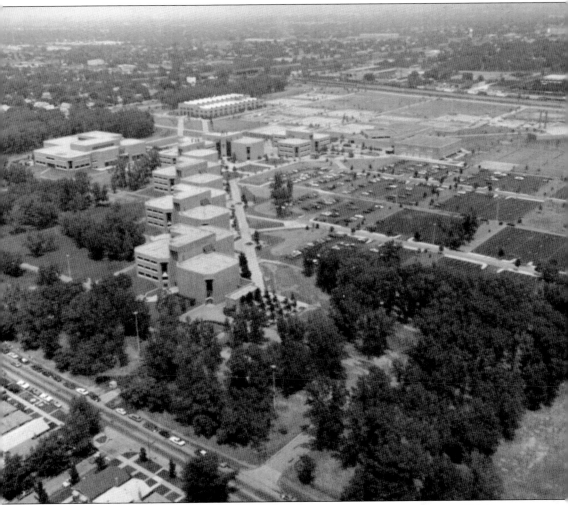

This c. 1980 aerial view shows the new Chicago State University campus at Ninety-fifth Street and King Drive. The view is facing northeast. The photograph shows how expansive the university became since its move to this location in 1968.

CSU president Dr. Benjamin Alexander wanted to have a diverse campus, which included not only the student body, faculty, and curriculum, but also the grounds. Alexander was instrumental in the landscaping and paving on the new campus. He also helped preserve wooded areas and designated a section of the campus as a natural prairie. CSU today looks very much like this photograph from the 1970s. There are still paved walking paths throughout the wooded and grassy areas. In 2007, a deer was spotted in the Prairie Garden. That sight was commemorated on the cover of the 2008–2010 student catalog.

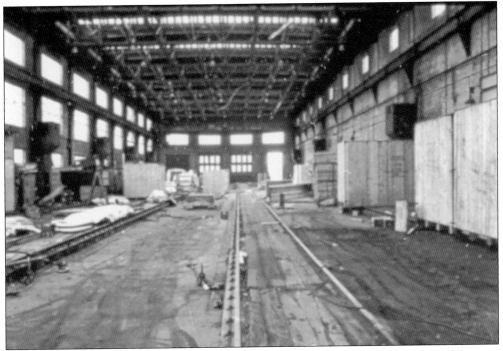

The Robinson University Center has been around since before the construction of the new campus. It was the original engine room for the Pullman Train Company, and there are still vestiges of its prior use. In the photograph above, remnants of the train tracks are visible. Over the years, the building housed classrooms, the child-care center, social spaces for students and the community, and administrative offices.

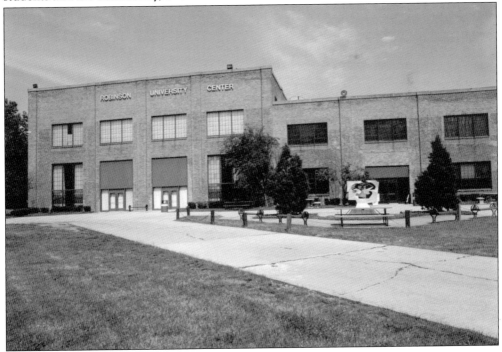

Jacoby D. Dickens (1931–2013) was president of Seaway Bank and Trust, once the largest black-owned bank in the country. In 1995–1996, he made the single largest contribution to CSU and was also instrumental in raising additional funds for the university. With his help, CSU was able to update its technological facilities. The Jacoby D. Dickens Physical Education and Athletics Center was dedicated on his behalf. (Courtesy of Byung-In Seo.)

Prior to 2007, collegiate volleyball and basketball competitions were held in this gymnasium. Since then, men's and women's basketball games have been held at the Jones Convocation Center. (Courtesy of Byung-In Seo.)

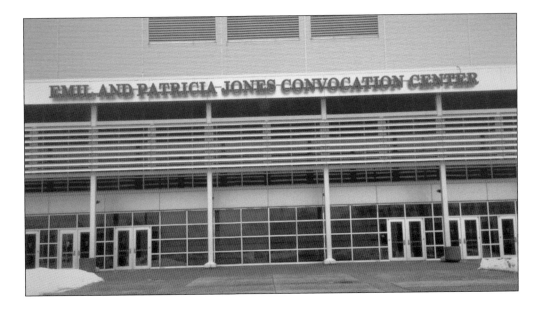

The Jones Convocation Center opened in 2007. This building is named for Emil Jones and his late wife, Patricia. Jones believed that CSU needed to have commencements on its own campus, instead of going to other venues. This venue hosts commencements, basketball games, concerts, and other events. It seats up to 7,000 people. The photograph below shows the stage set up for a commencement ceremony. (Both, courtesy of Byung-In Seo.)

In 2001, Chicago State University participated in Suite Home Chicago, an art exhibit featuring life-size fiberglass furniture designed by local artists. This sofa and television cabinet were part of an exhibit called "Suite Entrepreneurship," located in front of the Business and Health Sciences Building. On the back of the sofa is Madam C.J. Walker, one of the first female millionaires in the United States. She made her money by creating and selling beauty products. On the front of the cabinet is Jacoby Dickens, former president of Seaway Bank. (Both, courtesy of Byung-In Seo.)

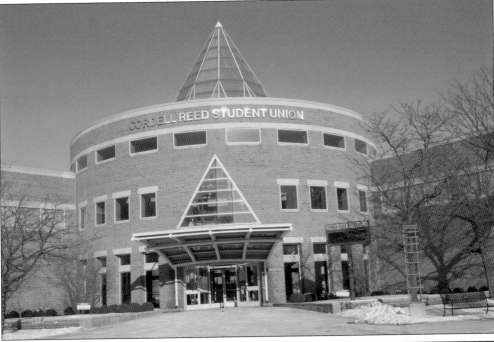

The Cordell Reed Student Union opened in 1992. The glass roof is shaped like an African hut, and the rotunda provides communal space for students, faculty, staff, and visitors. In 2001, it was dedicated to Cordell Reed, a mechanical engineer who became an executive of Commonwealth Edison Company. He was an ardent supporter of higher education and Chicago State University. (Courtesy of Byung-In Seo.)

The rotunda is a place for social and academic gatherings. Pictured here is Umajaa Market, an event that is open to the public. In 2016, the rotunda was dedicated to Ronald "Kwesi" Harris, the founder of the African American Male Resource Center and TEMBO. Through his efforts, he was able to raise the graduation rate of African American men at CSU by 300 percent. (Courtesy of Byung-In Seo.)

The Cook Administration Building is named after Raymond M. Cook, dean of Chicago Teachers College from 1948 to 1965. He reestablished graduate programs in library sciences and biological sciences and established the master of arts degree in education. (Courtesy of Byung-In Seo.)

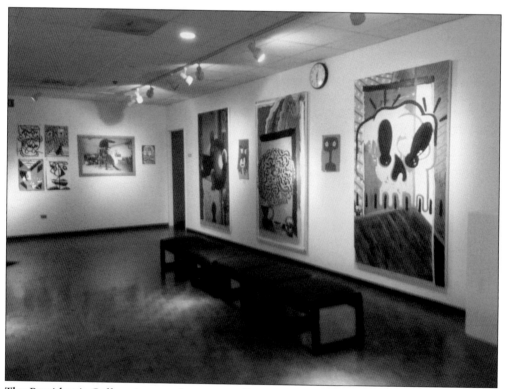

The President's Gallery is one of two art galleries on campus. Pieces from local, national, and international professional artists are featured here. The goal is to expose the CSU community to high-quality art that reflects diverse cultural themes and styles. (Courtesy of Byung-In Seo.)

In the lobby of the Cook Administration Building is the "Tree of Life." The sycamore tree connects wisdom and knowledge to ancestors and to nature itself. It also represents the first university in Kemet, in ancient Egypt. At the center of the tree are the heads of a queen and pharaoh. The queen represents female students, and the pharaoh represents the male students. The overlapping circles represent the circles of learning and the trinity of gods, which includes Aset (Isis, goddess and mother of Horus), Wsir (Osiris, god of rebirth or resurrection and father of Horus), and Herew (Horus, god of leadership and authority). This work represents the tradition of knowledge and learning at CSU. (Courtesy of Byung-In Seo.)

Douglas Hall is named after Sen. Paul and Rep. Emily Taft Douglas. Senator Douglas was considered to be a pioneer in civil rights, women's rights, and education. Representative Douglas worked to have mobile libraries in rural areas, and was a staunch advocate for civil rights. Originally, this building was the main campus library. Currently, it houses the Breakey Theatre, the television station, and the College of Pharmacy. (Courtesy of Byung-In Seo.)

Breakey Theatre has been the site of student and community theater productions, political rallies (including one for Sen. Carol Mosely Braun), the Mr. and Miss CSU pageant, musical performances (like CSU Jazz Fest), film screenings, town halls, and lectures (such as Cicely Tyson). It was dedicated to James D. Breakey in July 1980 for his community service. Breakey was CEO of the Stuart-Hooper Company, a board member of the CSU foundation, and worked for racial progress in business. (Courtesy of Byung-In Seo.)

CSU has a chapel on campus, the Parker Meditation Room. Elsie V. Parker, wife of Judge H. Parker of Parker House Sausage Company, asked Pres. Benjamin Alexander for space on campus to build a chapel. She believed that the students needed a spiritual component to their education. From the altar to the drapes, Elsie V. Parker provided everything for this space. Even though the Parker family is Christian, Elsie V. Parker wanted the chapel to be a space for all faiths. One can attend not only Ash Wednesday services and Bible study groups at the chapel, but also Friday evening Islamic prayer services. (Courtesy of Nancy Grim Hunter.)

The Daniel Hale Williams Science Building was named after Dr. Daniel Hale Williams, an African American doctor who was one of the founders of the Provident Hospital and Training School for Nurses in Chicago, and was the first doctor who performed open-heart surgery in 1893. Following Ella Flagg Young's vision, this building houses all science classes. (Courtesy of Byung-In Seo.)

In 2010, CSU opened up an aquaponics facility under the direction of Emmanuel Pratt, which brings together hydroponics (growing plants in water) and aquaculture (fish farming). In this photograph, the fish are in a tank between two sets of plants. The waste water from the fish water fertilizes and waters the plants. The facility provides a hands-on learning experience for CSU and City Colleges of Chicago students as well as community members and local schools via workshops, tours, and presentations given by CSU faculty and staff. The center has expanded curriculum offerings and spurred interest in urban agriculture. (Courtesy of Byung-In Seo.)

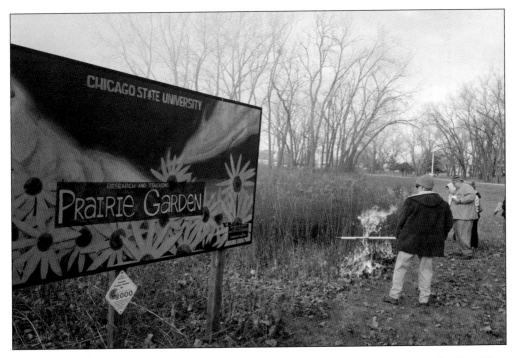

True to Pres. Benjamin Alexander's vision, the campus has a diverse topography. Land has been set aside for the Prairie Garden and Bird Habitat for Teaching and Research. These spaces are working classrooms. Students get hands-on experience working with flora and fauna. Unlike working in an enclosed laboratory, students are able to get a true understanding of life sciences within natural surroundings. (Both, courtesy of Susan Kirt.)

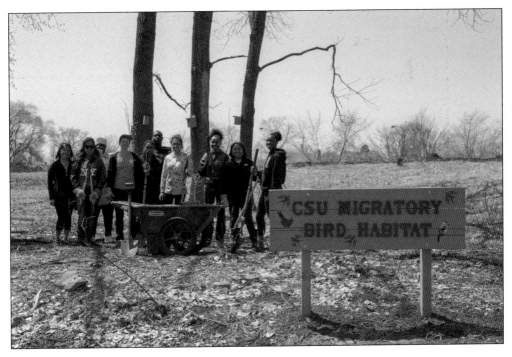

A new campus library opened in 2007 under the name New Academic Library. In 2017, the board of trustees dedicated it as the Gwendolyn Brooks Library. The library consists of several units, which work to provide opportunities for research, teaching, and learning. Additionally, the study rooms, auditorium, and the Dr. Julian Scheinbuks Sun Room serve as meeting spaces for student, community, and campus organizations. (Courtesy of Byung-In Seo.)

The Gwendolyn Brooks Library has a photographic exhibition and an archival collection from the Illinois Legislative Black Caucus. The images show members of the caucus, some of whom are CSU alumni and have worked to provide CSU with financial and legislative support. Pictured against this wall of esteemed individuals are CSU professors Drs. Kimberly Black, Kim Dulaney, and Byung-In Seo. (Courtesy of Byung-In Seo.)

In 2010, beloved professor Dr. Julian Scheinbuks passed away. He bequeathed to the university $1 million as a way to repay everything that he received from CSU. The Sun Room is dedicated to him. This space is used for social and academic gatherings. Its doors open to an outdoor terrace. (Both, courtesy of Byung-In Seo.)

To honor his generous donation to Chicago State University and commitment to Biology Education and Distance Learning, President Wayne D. Watson and the CSU Board of Trustees officially dedicate this room the:

Dr. Julian Scheinbuks
Sun Room and Terrace

May 24, 2011

The Education Building was one of the first buildings on campus. It opened in 1973 to much fanfare. This building houses all education courses, a reading laboratory, a student study and testing center, and a computer laboratory. While students across all majors use this building, its facilities are primarily geared for students with an education major.

In 2017, CSU turned 150 years old. Over the years, the university has thrived and grown and has also encountered financial and enrollment difficulties. There have been repeated threats of closure, but with student and faculty support, it has weathered the stormy times. History has shown that CSU is progressive and resilient. These banners are flown across campus and in the community as a sign of its success. (Courtesy of Byung-In Seo.)

Dzyladzisehovic ♡
#10
CLASS of SPRING
2017
Once a cougar, always
a COUGAR ♡
Thanks Chicago State for
being part of this!

From its inception, students at CSU have known that the administrators, faculty, and staff have their best interests at heart. Whether it is in education, STEM, humanities, social sciences, or health sciences, student learning has been a priority. Throughout the Jacoby D. Dickens Physical Education and Athletic Center are signs of student affection and appreciation for the university. This signature found by the women's locker room says it all. (Courtesy of Byung-In Seo.)

BIBLIOGRAPHY

Byrd, Milton. *Focus on the Seventies.* Chicago, IL: Chicago State College, 1970.

Chicago Board of Education. *Report of the Sub-Committee on the Teachers Colleges of the Study Committee on Higher Education.* Chicago, IL: Chicago Board of Education, 1964.

College of Education. *Our History.* Chicago State University, 2018. www.csu.edu/collegeofeducation/history.htm.

Cook, Raymond M. *Letter to Edward E. Keener, Department of Personnel.* Chicago, IL: Chicago Teachers College, 1950.

———. *Letter to Harold C. Hunt, General Superintendent of Schools.* Chicago, IL: Chicago Teachers College, 1951.

———. *Letter to Eileen C. Stack, Associate Superintendent for Higher Education.* Chicago, IL: Chicago Teachers College, 1963.

———. *Letter to Eileen C. Stack, Associate Superintendent for Higher Education.* Chicago, IL: Chicago Teachers College, 1965.

Illinois Teachers College Chicago—South: Highlights of Its Past, Present, and Future. Chicago, IL: Illinois Teachers College, 1967.

Kearney, Edmund W. *Chicago State College 1869–1969: A Centennial Retrospective.* Chicago, IL: Chicago Teachers College, 1969.

Kearney, Edmund W., and E. Maynard Moore. *A History: Chicago State University 1867–1979.* Chicago, IL: Chicago State University Foundation, 1979.

Office of Institutional Effectiveness and Research. *Chicago State University Factbook, 2015–2016.* Chicago State University, 2018. www.csu.edu/IER/documents/factBook2015-2016.pdf.

Office of the Superintendent of Public Instruction. *Thirteenth Biennial Report of the Superintendent of Public Instruction, State of Illinois, October 1, 1878–June 30, 1880.* Springfield, IL: 1881.

Report of the General Superintendent of Schools to the Board of Education. 1956.

Stack, Eileen C. *Letter to Raymond Cook and Jerome Sachs.* Chicago, IL: Board of Education, 1964.

Willis, B.C. *History of Chicago Teachers College: A Report.* Chicago, IL: Board of Education, 1956.

———. *The Report to the General Superintendent of Schools to the Board of Education.* Chicago, IL: Chicago Teachers College, 1956.

Your Chicago Teachers College 1946–1947. Chicago, IL: Chicago Teachers College, 1946.

DISCOVER THOUSANDS OF LOCAL HISTORY BOOKS FEATURING MILLIONS OF VINTAGE IMAGES

Arcadia Publishing, the leading local history publisher in the United States, is committed to making history accessible and meaningful through publishing books that celebrate and preserve the heritage of America's people and places.

Find more books like this at
www.arcadiapublishing.com

Search for your hometown history, your old stomping grounds, and even your favorite sports team.

Consistent with our mission to preserve history on a local level, this book was printed in South Carolina on American-made paper and manufactured entirely in the United States. Products carrying the accredited Forest Stewardship Council (FSC) label are printed on 100 percent FSC-certified paper.

MADE IN THE USA